MIND CONTROL, OSWALD & JFK:

Were We Controlled?

by
Lincoln Lawrence
& Kenn Thomas

Adventures Unlimited Press

MIND CONTROL, OSWALD & JFK:

Were We Controlled?

"The only thing necessary for the triumph of
evil is for good men to do nothing."
–Edmund Burke

"I hereby appoint the the Warren Commission."
–Lyndon B. Johnson

MIND-CONTROL, OSWALD & JFK
Were We Controlled?

by Kenn Thomas & Lincoln Lawrence

Were We Controlled?
©1967 by Lincoln Lawrence

This edition and introduction
© 1997 Ken Thomas

ISBN 0-932813-46-1

Printed in the United States of America

Published by
Adventures Unlimited Press
One Adventure Place
Kempton, Illinois 60946 USA

Other Books in the Mind-Control/Conspiracy Series:
MIND-CONTROL-WORLD CONTROL: The Encyclopedia of Mind Control
NASA, NAZIS & JFK: The Torbitt Document & the JFK Assassination
MIND-CONTROL, OSWALD & JFK: Were We Controlled?
THE GEMSTONE FILE: Howard Hughes, Onassis & JFK
LIQUID CONSPIRACY: JFK, LSD, the CIA, Area 51 & UFOs

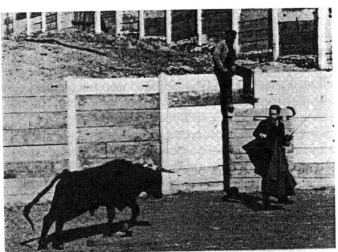

Top: José Delgado of Yale University's School of Medicine faces a charging bull... Bottom: ...and stops it cold, using a "stimoceiver," which sent a radio signal to its brain through an implant. These photographs appeared on the front pages of newspapers around the world, including the New York Times (May 17, 1965).

RADIO 'MATADOR' STOPS WIRED BULL

Continued From Page 1, Col. 5

our understanding of the mind."

"We are in a precarious race," he said, "between the acquisition of many megatons of destructive power and the development of intelligent human beings who will make intelligent use of the formidible forces at our disposal."

Based on His Experiments

Dr. Delgado's contention that brain research has reached a stage of refinement where it can contribute to the solution of some of these problems is based he said, on many of his own experiments.

These have shown, he explained, that "functions traditionally related to the psyche, such as friendliness, pleasure or verbal expression, can be induced, modified and inhibited by direct electrical stimulation of the brain."

For example, he has been able to "play" monkeys and cats 'like little electronic toys" that yawn, hide, fight, play, mate and go to sleep on command.

And with humans under treatment for epilepsy, he has increased word output sixfold in one person, has produced severe anxiety in another, and in several others has induced feelings

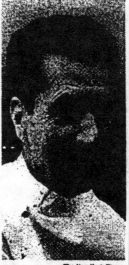

The New York Times
STUDYING BEHAVIOR: Dr. José M. R. Delgado in his office at Yale University School of Medicine.

Switzerland used a similar setup to stimulate various cerebral regions in conscious cats. He showed that electrical currents could influence the animal's posture, balance, movement and such basic psychic manifestations as fear and rage.

For some still unexplained reason, those techniques were

those films a
of all the an
the behavior
This permits
tive assessmen
social interact:
quantification
havioral profi
said. This is
portant when
modifications i
of the group p
stimulation of
sponse in one
animals.

For exampl
several specifi
brain can indu
in a monkey, I
tive data on t
havior, as we
others in the
more precisel:
of various, s
effects of el
tion on individ
social behavioi

Some of the
With such
Delgado has
¶Monkeys w
a button that
to the brain
member of
calms it down
animals can b
trol one anoth
¶A monkey,
tremely aggr
will make "int
only on compet
the colony,
friendlier, ones
¶Monkeys a
triggered into
havior in whiel
its mouth, turr

Delgado in 1965.

Right: Delgado in 1995. The humanist magazine Free Enquiry described him as "one of the most noted researchers on the brain."

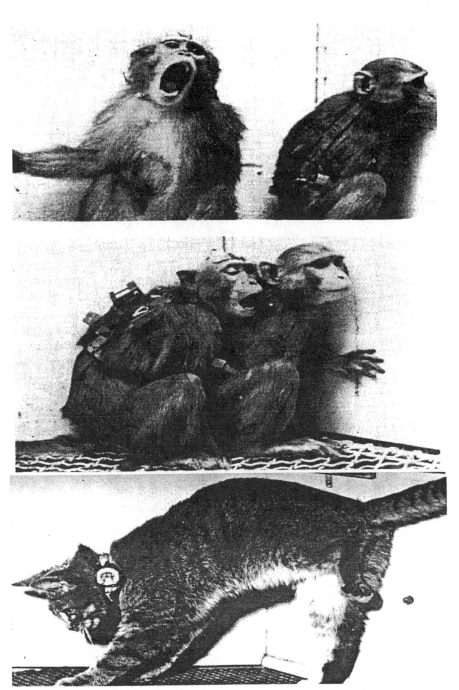

Above: Delgado's experiments with wired-up monkeys and cats. From *Evolution of the Physical Control of the Brain* by José Delgado, M.D. (1965).

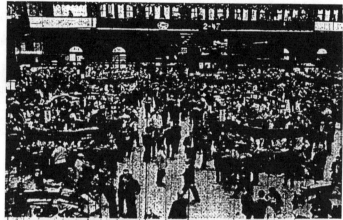

BIG BOARD SUSPENDS TRADING: Brokers at the New York Stock Exchange discuss the assassination of President Kennedy. Trading on floor was suspended at 2:07 P.M.

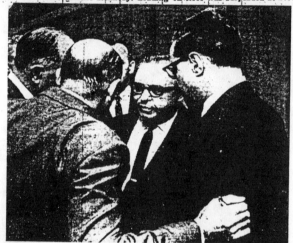

Top: Stock market officials faced a major crisis when JFK was murdered. 2.6 million shares were traded in an unparalledl sell-off. The board of governors of the stock exchange closed the market 83 minutes early, at 2:07 PM. Bottom: Tino de Angelis, the third mind control victim according to *Were We Controlled?*, is the second man from the right in this photo. The others are officers and council for Allied Crude Vegetable Oil and Refining Company.

Left: From Wilhelm Reich's 1945 *The Bioelectrical Investigation of Sexuality and Anxiety*. Right: Original 1967 dust-jacket of *Were We Controlled?*

THE NEW YORK TIMES, MONDAY, APRIL 15, 1968

DAMON RUNYON JR. IS KILLED IN PLUNGE

WASHINGTON, April 14 (UPI) —Damon Runyon Jr., whose father was one of the most famous newsmen of a generation ago, fell to his death from an overpass in Rock Creek Park here today.

The police tentatively ruled Mr. Runyon's death a suicide. He was pronounced dead on arrival at Georgetown University Hospital 15 minutes after he plunged from the P Street Bridge, the police said.

Mr. Runyon was feature editor for the weekly D.C. Examiner at the time of his death. He had previously worked for a number of newspapers, including the New York Herald Tribune and its successor, The World Journal Tribune, and the old International-News Service.

His father was a sports writer, columnist and short-story writer.

Mr. Runyon, who was 48 years old, had been divorced from his wife several years ago. Two children survive.

Above: Damon Runyon, Jr. died under mysterious circumstances while working on a condensation of *Were We Controlled?* for the *National Enquirer*.

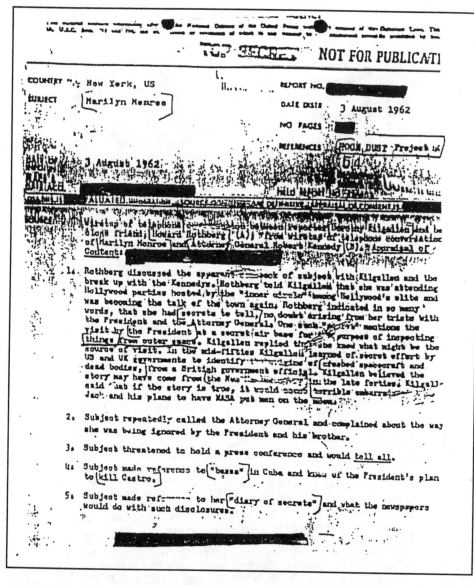

COUNTRY : New York, US REPORT NO. ▮▮▮▮

SUBJECT : Marilyn Monroe DATE DISTR 3 August 1962

NO PAGES ▮

REFERENCES MOON DUST Project ▮▮

3 August 1962 ▮▮▮

SOURCE

Wiretap of telephone conversation between reporter Dorothy Kilgallen and her close friend, Howard Rothberg (A) from wiretap of telephone conversation of Marilyn Monroe and Attorney General Robert Kennedy (B). Appraisal of Contents:

1. Rothberg discussed the apparent break of subject with Kilgallen and the break up with the Kennedys. Rothberg told Kilgallen that she was attending Hollywood parties hosted by the "inner circle" among Hollywood's elite and was becoming the talk of the town again. Rothberg indicated in so many words, that she had secrets to tell, no doubt arising from her trists with the President and the Attorney General. One such "secret" mentions the visit by the President at a secret air base for the purpose of inspecting things from outer space. Kilgallen replied that she knew what might be the source of visit. In the mid-fifties Kilgallen learned of secret effort by US and UK governments to identify the origins of crashed spacecraft and dead bodies, from a British government official. Kilgallen believed the story may have come from the New ▮▮▮▮▮ in the late forties. Kilgallen said that if the story is true, it would cause terrible embarrassment for Jack and his plans to have NASA put men on the moon.

2. Subject repeatedly called the Attorney General and complained about the way she was being ignored by the President and his brother.

3. Subject threatened to hold a press conference and would tell all.

4. Subject made reference to "bases" in Cuba and knew of the President's plan to kill Castro.

5. Subject made reference to her "diary of secrets" and what the newspapers would do with such disclosures.

A "Top Secret" report on Marilyn Monroe and Dorothy Killgallen. It is a memoranda discussing a transcript of a wiretapped conversation between Howard Rothberg and Dorothy Kilgallen, the newspaper columnist quoted by Lincoln Lawrence who referred to Reich's cloudbusting as a means of mind control. Kilgallen and Rothberg discuss Marilyn Monroe's claim that JFK took her to "a secret airbase for the purpose of inspecting things from outer space." Reich had used cloudbusting in his encounters with UFOs. Killgallen was later murdered.

INTRODUCTION

"Were We Controlled? That is the question."

by Kenn Thomas

"Did you hear about the theory that Oswald got an electrode implanted in his brain during a hospital stay for an adenoid operation in Minsk?" Author Norman Mailer received the question during his press conference at the third annual Assassination Symposium on Kennedy in Dallas, November 18, 1993. At the time, Mailer's book, *Oswald's Tale*, had not been published, but word had it that the book in part presented a biography of Lee Harvey Oswald's life in the Soviet city of Minsk (1). Mailer looked at the questioner, a *Steamshovel Press* representative (2), like he was nuts and explained that he had never heard of the theory.(3)

Mailer had a long and ambiguous relationship with the community of JFK assassination critics and a *realpolitik* situation with his own broad, mainstream audience. When it finally appeared in print, his book relied on suspect sources and reached conventional conclusions. (4) Small wonder that he dismissed the basic premise of *Were We Controlled?* by Lincoln Lawrence, although it should have been easily recognizable to any student of the assassination. *Were We Controlled?* belongs to a

triumvirate of the most *outre* speculation about the JFK murder and its possible roots in Soviet mind control, including Michael Eddowes 1977 book *The Oswald File*, which led to the exhumation of Oswald's corpse (5), and Edward Epstein's 1978 *Legend*, claiming that Oswald worked for the Komitet Gosudarstvennoy Bezopasnosti, or KGB (6).

The KGB certainly felt high anxiety when police arrested Oswald for the murder of Kennedy. In his history of the KGB, writer John Barron reports that Yuri Nosenko, a defector sentenced to torture and confinement for years under CIA counter-intelligence head James Jesus Angleton, told him that "the anxiety was so intense that the KGB dispatched a bomber to Minsk to fly his file to Moscow overnight...officers crowded around the bulky dossier, dreading as they turned each page that the next might reveal some relationship between Oswald and the KGB." (7) Barron speculates that the KGB worried about American public opinion, and it may have been considering the implications for global armageddon that KGB involvement in the JFK assassination represented (8), but it seems more likely that those Soviet officers feared what all secret agencies fear most: exposure of their methods and techniques of espionage.

Did this involve mind control? Lee Harvey Oswald clearly was not unfamiliar with the term. In the summer of 1962, he came to the office of

New Orleans assistant district attorney Edward
Gillen and asked him about LSD. He told Gillen
that he had a supplier, inquired about its legality,
and made several references to Aldous Huxley's
Brave New World, a classic in the literature of
psychoactive drugs (9). Historians note that at the
time the CIA served as one of the few LSD
suppliers (10), emphasizing that it was used in
human experimentation and mind control among
the Marines at the Atsugi Naval Air Base where
Oswald served in Japan. One Marine from
Oswald's unit even confessed that he had been one
of the human subjects. One analyst suggested that
Oswald making himself visible in this way, on this
topic, with a public official, may have been
another attempt to establish an image for himself
as a dope-taking Commie symp. (11) Of course,
Oswald may have had a genuine curiosity about
the drug.

In any event, *Were We Controlled?* does not
argue for drug-induced mind control. Instead, it
posits that two methods--Radio Hypnotic
Intracerebral Control (RHIC) and Electronic
Dissolution of Memory (EDOM)--influenced the
behavior of both Oswald and Oswald's assassin,
Jack Ruby, as well as the actions of "vegetable oil"
swindler Tino De Angelis, who rode the
downward wave of the stock market on
assassination day. The first sixty pages of the
book give the science and history of
RHIC/EDOM, which it claims grew out of the

work of Yale professor Jose Delgado. In 1965, Delgado made headlines by stopping a charging bull in its tracks with a press of the button on a transmitter, sending electrical stimulation to the animal's wired-up brain. The book follows a discussion of this with its basic story: according to "The Rumor", Oswald had been manipulated by "The Group", headed by "Mr. One", to have a radio receiver surgically placed in his brain by "The Professor" (which *Were We Controlled?* suggests strongly was Delgado or an associate, as part of a Soviet/KGB behavior control program) while he ostensibly underwent an adenoid operation in Minsk. Oswald became a "sleeper", available anytime to perform assassinations at the will of a remote controller. Moreover, The Group then hypnotized Jack Ruby and with more advanced RHIC techniques caused him to kill Oswald. The Group's ultimate purpose, according to *Were We Controlled?*, was to have Kennedy assassinated at the exact moment RHIC-controlled De Angelis completed suicidal business transactions that led to a half billion dollar criminal profit for The Group through short-selling during the market panic of November 22, 1963.

Sound a little improbable? Even the book asks the question. Nevertheless, Jose Delgado's work is demonstrably real, as are its roots in Russian neurology and radio control of the brain, and in the 1930s Soviet study of hypnogenic mental suggestion. The psuedononymous Lincoln

Lawrence outlines the scholarship in the first part of the book. Delgado published his conclusions from the bull-stopping episode in 1969 (12). As late as 1995, he continued to argue that, "reality, for example, a landscape or a book, cannot penetrate the brain, which only accepts chemical and electrical codes," that "Human beings are *not born free* but are products of their genes," and that a "new economic and political system based on scientific reality is necessary." (13) Delgado's enthusiasm for the social engineering applications of his scientific findings have not diminished in the thirty years since the publication of *Were We Controlled?* It has, in fact, made him a revered figure among humanists, even though the limitations of the kind of behaviorism he suggests have long been exposed and examined by other humanist scholars. (14)

Scholarship suggests, too, that Jack Ruby did have his encounters with the controllers. In 1964, a psychiatrist named Louis Joylon West visited Ruby in jail and diagnosed him as "paranoid", in part because Ruby refused to recognize his own presumed mental illness. West had previously done to an elephant with LSD what Delgado had done to the bull using electrical stimulation; he felled the beast as part of a drug experiment at the University of Oklahoma, where he served as the head of the department of psychiatry in the 1950s and 60s. West also helped plan Ronald Reagan's notorious Center for the

Study and Reduction of Violence, an extension of
the equally notorious Vacaville prison brainwash
operations. It would have treated prisoners--and
even "pre-delinquent" children tracked on
PROMIS-like computer software (15)--with
psychoactive drugs, lobotomies and chemical
castration if the California legislature had not, in
its wisdom, stopped the project (16). CNN
interviewed West as a terrorism expert the day
after the Oklahoma City bomb and he
subsequently became a psychiatric consultant on
the case suspected bomber Timothy McVeigh, who
claims to have a mind control implant.

Lincoln Lawrence also certainly did not
create the character of Tino De Angelo or
fabricate the stock activity on the day JFK died.
As he notes, Norman C. Miller tells the story of
De Angelo's "vegetable oil" rip-off in his 1965
book, *The Great Salad Oil Swindle.* (17) *Were We
Controlled?* discusses at great length the
complexities of the market forces that day, but the
short version, shorn of all discussion of RHIC and
EDOM, maintains simply that De Angelis
borrowed money on receipts from an American
Express warehouse for tons of non-existent
cooking oil. After exposure of the fraud, an
investor from Omaha, Nebraska, Warren Buffet,
bought a great deal of American Express stock and
realized a huge benefit when the scandal failed to
affect the company's renown charge card service.
(18) But as one financial analyst put it: "De

Angelo's highly leveraged machinations resulted in the bankruptcy of Allied Crude Vegetable Oil Refining Corporation, the country's largest supplier of edible oils for export. That one bankruptcy led to the failure of more than 20 banks and commodities and securities firms. Many of those firms unwittingly used warehouse receipts for the salad oil as collateral for bank loans of $150 million. Unfortunately, creditors discovered that a large portion of the edible oils purportedly stored in Allied's tanks, or the connected tanks of other companies, was missing. Actually, a lot of those commodities never existed at all. What happened to the money? Some observers suggested that De Angelis probably routed it to confederates who were able to hide it. As the business of banking and finance expanded internationally, criminal cooperation became disturbingly widespread and sophisticated; a loosely linked worldwide cadre of swindlers used complex corporate techniques..."(19)

Interestingly, when De Angelis re-emerged from jail, he also reappeared in the swindle news. After serving seven years of a twenty year sentence over the vegetable oil fraud, De Angelis established Rex Pork Company in 1972, which reached $20 million in sales by the following year. Despite that initial success, the Department of Agriculture soon began receiving complaints from pork dealers about bounced checks and unpaid bills for hogs and "little porkers." It eventually filed charges against Rex Pork for debts that exceeded three

million dollars, and one creditor used a court order to raid one of De Angelis' "little porker" warehouses and sold the meat to recover the debt. (20) Again in December 1992 he was arrested in upstate New York in a $1 million dollar pork product swindle of the Maple Leaf Foods unit of Fearmans Fresh Meats, a meat company in Ontario, Canada. A federal judge sentenced him to 21 months in prison and fined him $4000. (21) This career criminality argues against Lincoln Lawrence's attribution of De Angelis' improbable scams and behavior to mind control, although clearly the lesser swindles of De Angelis' later days argue for a diminished capacity, after prison and perhaps after deprogramming from RHIC/EDOM manipulation.

One measure of the veracity of the mind control claims in *Were We Controlled?* is its durability as an urban legend. Oswald's fellow Marine Kerry Thornley has long described his belief that he received a RHIC-like brain implant after getting involved in an ancillary JFK plot with E. Howard Hunt. (22) EDOM-like hypnogenic regression is discussed at length in the classic mind-control work, *The Control of Candy Jones*, a study of the wife of Long John Nebel, a radio talk show personality mentioned in *Were We Controlled?* (23). Similar claims have also recently been made by a woman named Cathy O'Brien, that she was turned into a sex slave for the intelligence community as part of a covert

program called Operation Monarch (24). The suspect in the Oklahoma City bomb case, Timothy McVeigh, told his friend Phil Morawski that the Army implanted a microchip in his buttocks, for tracking purposes and, according to one source, mind control. At one point McVeigh worked for Burns International Security Service's Calspan operation in Buffalo, NY, which includes electronic telemetric devices among its many products. (25)

Injectable transponders for animal control currently do exist, as do fears about the people population control possibilities of proposed "smart" ID cards, containing several gigabytes of personal and bank data readable with the pass of a police scanner/baton over an innocent citizen's pants pocket. One scientist at the Stanford University Center readily acknowledges his work in developing needle cortical probes to map and monitor the brain, remarking that the National Institute of Health had a neural prosthesis program "as early as 1971." (26) This "Mark of the Beast" invokes powerful imagery at one religious end of social spectrum; at another end young bioengineers worry that their Mad Doctor image may impede the medical good of such research. Common opinion is heavily weighted against the religious fanatics, but *Were We Controlled?* notes that brain implant science actually had more than thirty years of history by the time Jose Delgado developed his "stimoceiver" and stopped the bull.

In all that time, legitimate medical applications of the technology have been slow in coming, while tales of terror multiply. Who can say which side in this debate is more naive?

Were We Controlled? leaves one last dangling footnote, to the psychologist Wilhelm Reich. In its last pages, the book lauds newspaper columnist Dorothy Kilgallen, whose private interview with Jack Ruby disappeared after her own mysterious death, for being "the first to sound a serious warning in print to the general public about thought control." On December 21, 1964 she reported on an effort by military scientists "to explore the ramifications of 'cloud-busting' which in its refined stages means thought control." Reich invented the technology of cloudbusting--pipelike cannons designed to redirect atmospheric orgone flow--actually for the purpose of weather control. He later discovered the cloudbuster had an effect on the UFOs he observed at his laboratory and during an expedition to Tucson, Arizona (a trip that incidentally took him through Roswell, New Mexico.) Reich dutifully reported all of his findings to the Air Force, which even set up meetings with Reich's assistants, but it ultimately feigned disinterest in cloudbusting. Reich died in jail in late 1957--seven years before Kilgallen's report (27)--still insisting, probably rightly, that the Eisenhower administration maintained interest in his work. Reich's work had little to do with

thought control, however. He had spent his life, in fact, trying to effect the opposite by empowering his patients with the skills to deal with life energy currents. How would the military apply his findings, though, and in what directions would it develop them over seven years? Perhaps Kilgallen provides the chilling answer. (28)

Posthumous events in Dorothy Kilgallen's life added a few more chills. Shortly after she died on November 7, 1965, the eastern seaboard of the United States suffered a historic electrical blackout, accompanied by reports of many UFO sightings. In 1996, investigator Miro Speriglio surfaced a transcript of a wiretapped conversation between Kilgallen and a friend, Howard Rothberg (29) concerning Marilyn Monroe's boast at a Hollywood party about her knowledge of "a visit by the President at a secret air base for the purpose of inspecting things from outer space." Area 51? The Roswell aliens? Another fraud or hoax? On February 16, 1957 Wilhelm Reich wrote to J. Edgar Hoover, in a letter recovered through the Freedom of Information Act in 1992, claiming that "This morning, appx. 8 am, shortly before the delivery a printed document by bellboy, a voice, disguised as 'Marilyn Monroe' called my unlisted telephone saying things incomprehensible to me, ending with 'I am only kidding.'"

Perhaps a final measure of how seriously readers should take *Were We Controlled?* involves the history of the book itself. Author Dick

Russell, in *The Man Who Knew Too Much*, his
monumental study of the spook Richard Case
Nagell, reports an October 1976 exchange with
Art Ford, a radio announcer who claimed to have
done research work for Lincoln Lawrence:
"'Lawrence' had a lawyer, Martin Scheiman, whose
role was to pay out royalties up to a certain point.
He was found dead in the Time-Life Building, with
a gun beside him and a bullet through his head
after the book was published, a supposed suicide.
Damon Runyon, Jr., did a condensation of the
book for *National Enquirer*, which never published
it. He was the only person to ever receive a
written communication from 'Lawrence.' He
ended up being pushed off a bridge in Washington,
DC." (30) (*Were We Controlled?* notes the high
regard in which both newsman Damon Runyon
and Ernest Hemingway held newspaper columnist
Dorothy Kilgallen.) Russell also notes that in late
1967 Lee Harvey Oswald's mother Marguerite
called respected researcher Mary Ferrell after
reading *Were We Controlled?* and exclaimed "I've
got to find out who wrote this book, because he
knew my son." Ferrell later found a passage in
Warren Commission testimony suggesting that
Marguerite Oswald may have discovered some
evidence on an implant while rubbing her son's
head, discovering also that his hair texture had
changed. Russell adds that Oswald's brother
Robert also told *Legend* author Edward Epstein
that his brother's hair texture had changed when

he returned from the USSR, something he attributed to the possibility of electro-shock or other medical treatment. Ferrell also met with Art Ford in 1973 and found him believable.

Readers of the current volume are, as always, invited to accept or dismiss these events and opinions to taste.

Kenn Thomas
April 13, 1997

Notes:

(1) Mailer, Norman, *Oswald's Tale*, New York: Random House, 1995.

(2) *Steamshovel Press*, POB 23715, St. Louis, MO 63121. The magazine regularly examines conspiracy theories and costs $6 per issue; $23 for a four issue subscription.

(3) Documentary videographers Keith Preston and Sean Mansfield videotaped this exchange.

(4) As researcher John Judge put it in *Steamshovel Press* #14 (Fall 1995):

"It was clear to me in interviews when Mailer was asked why he chose to do this book on Oswald, he based it on the fact that Lawrence Schiller had gotten private access to the Minsk KGB files on Oswald and was willing to share

those with Mailer. It's hard for me to imagine that
Schiller was able to get those kind of documents
based on his access to the KGB there or some sort
of salesmanship. I would think that in order to
crack that nut you would have to have some links
to current KGB and US intelligence
interconnections.

Schiller goes back at least as far as 1967 as
the source to the very first character assassination
attack on the critical community in a book called
Scavengers and Critics of the Warren Commission
by Warren Lewis. The subtitle of that book is
'Based on an Investigation by Lawrence Schiller' [a
similar subtitle also appeared Albert Goldman's
smear biography of Lenny Bruce, *Ladies and
Gentlemen, Lenny Bruce!*, Random House, 1974.].

I think Mailer, who funded the original
Assassination Information Bureau, the Carl
Oglesby operation in the 1970s that led to the
House Select Committee, is basically allowing
himself an out...that book slams Sylvia Meaghre,
Penn Jones, Harold Weisberg, a lot of the early
critics are downplayed in that book and their
personal quirks are pointed out...Maybe there is a
separate agenda at work here. If you discredit parts
of the community, but certainly that early book
attacks almost the whole community, and yet at
the same time he shows up later as one of the
defenders of people looking into the truth. He
talked in those years of forming a People's CIA,
now he seems to be much more back in bed in a

clear way with the intelligence community, or at least some segment of it. Maybe he feels disenfranchised, I don't know. *Harlot's Ghost* [Mailer's previous book] is an interesting book in that it takes the other tack, that Oswald may have been a lone assassin but he was at least connected enough to the intelligence community that he was upsetting all the apple carts.

This [*Oswald's Tale*] is the last book in a four book contract. He's basically edged into a position where he won't come all the way out and say that Oswald did it because he knows it's not true. He can't base it on the evidence. He says you can't get in to the miasma of the evidence, we have to get to the other questions, which is why did Oswald choose Kennedy as his victim? Well, if you can't prove that Oswald shot Kennedy, it's useless to discuss why he chose Kennedy."

(5) Eddowes, Michael, *The Oswald File*, New York: Clarkson N. Potter, 1977.

(6) Epstein, Edward, *Legend*, New York: McGraw-Hill, 1978.

(7) Barron, John, *KGB: The Secret Work of Soviet Secret Agents*, Toronto: Bantam, 1974, p. 452.

(8) Scott Peter Dale, *Deep Politics II*, Skokie, IL: Green Archives, 1995, pp. 35, 71, 78. Peter Dale Scott argues that rumors about a possible Oswald-

KGB link comprised a "phase one" disinformation campaign that in part gave Lyndon Johnson enough moral authority with Warren Commission members to get them to produce their lone gunman conclusions, thus avoiding nuclear war with the Soviets. That such a link would embarrass the FBI, which "should have pursued a whole schedule of statutory and administrative requirements...which had not been followed in this case" required a "phase two" cover-up. *Deep Politics II* also provides good analysis of a phone call made to KGB agent Valeriy Kostikov at the Soviet embassy in Mexico by someone identifying himself as "Lee Oswald" in October 1963.

(9) Huxley, Aldous, *Brave New World*, Chatto and Windus, Ltd., 1932. Interestingly, Huxley died the same day as JFK, after his wife Laura gave him a final dose of the psychedelic drug. As she tells it: "Some time during the morning, a new tank of oxygen [for Aldous Huxley's medical treatment] was brought in by a young man who had come several times before. He started, rather loudly, to say, 'Did you hear that President Kennedy...' I stopped him with a look. Aldous did not notice, maybe because he was preoccupied about the [young man's] tip. 'Those tanks are heavy; give him a dollar.'" (Horowitz, Michael and Palmer, Cynthia, *Moksha: Writings on Psychedelics and the Visionary Experience*, Los Angeles: J. P. Tarcher, Inc., 1977.)

The New Orleans Public Library records that Oswald borrowed two books by Huxley in September 1963. (Lee, Martin A., Ranftel, Robert, and Cohen, Jeff, "Did Lee Harvey Oswald Drop Acid?", *Rolling Stone*, March 3, 1983.)

(10) Groden, Robert, J., *The Search For Lee Harvey Oswald: A Comprehensive Photographic Record*, London: Bloomsbury Publishing Plc., 1995, p. 30. This book lives up to its subtitle. Groden served as as expert witness for the defense in O. J. Simpson's civil trial, raising legitimate questions about one photograph of the Italian-made Bruno Magli shoes ostensibly worn by Simpson.

(11) Hurt, Henry, *Reasonable Doubt*, New York: Henry Holt and Company, 1985, p. 303-304. Hurt also makes an observation about the relationship of the CIA's MKULTRA mind control experiments to the KGB: "The ultimate goals were to offset enemy efforts..." (p. 303.)

(12) Delgado, Jose, *Physical Control of the Mind: Toward a Psycho-Civilized Society*, New York: Harper & Rowe, 1969.

(13) Delgado, Jose, "Neurological Bases of Modern Humanism," *Free Inquiry*, Vol. 15, No. 4, Fall 1995, pp. 25-28. The article makes no mention of Jose Delgado's battle with the bull, the most famous, headline-making incident of his career.

(14) Arthur Koestler, for instance, demonstrates in *The Act of Creation* (MacMillan, 1964) that mental codes and matrices often "bisociate" and lead to scientific and artistic discovery, not simply control and manipulation. "Behaviourism, the dominant school of contemporary psychology, is inclined to take a view of man which reduces him to the station of that of patient, and the human condition to that of a conditioned automaton." To the extent that behaviorism and operant conditioning permeates consumerism, it has tremendous value to transnational corporate suppliers of goods and service. In this sense, we are all controlled.

(15) Before his mysterious death, investigator Danny Casolaro researched PROMIS, a tracking software appropriated from a group called Inslaw by the Justice Department under Reagan, his attorney general Ed Meese and crony Earl Brian. Casolaro connected PROMIS to an international cabal similar to the one described by Lincoln Lawrence. Casolaro called it the Octopus; its existence is chronicled in a book based on Casolaro's research entitled *The Octopus: Secret Government and the Death of Danny Casolaro* by Kenn Thomas and Jim Keith ($23 from Feral House, POB 3466, Portland, OR 97208.) *Were We Controlled?* identifies one of the corporations involved with Tino De Angelis' stock market improprieties as "sometimes dubbed by financial writers as 'The Octopus.'" (p. 118). Also, a major

source for information on Tino De Angelo's later career is Jonathan Kwitny, whose book *Crimes of the Patriots* (Touchstone, 1988), informed Casolaro's understanding of Octopus involvement in the Nugan Hand bank scandal.

(16) Lee, Martin A., and Shalin, Bruce, *Acid Dreams*, New York: Grove Press, 1985, pp. 189-190.

(17) Miller, Norman C., *The Great Salad Oil Swindle*, New York: Coward McCann, 1965.

(18) Lenzer, Robert, "Give Thanks There Aren't More Con Men," *Boston Globe*, November 28, 1991, p. 78.

(19) Govoni, Stephen, "Villainy Observed: A Lineup of Scoundrels Part II -- The Rogues," *Financial World*, September 16, 1986.

(20) Kwitny, Jonathan, "Tino De Angelis, In The Pork Games, Stirs a Lot of Squeals," *Wall Street Journal*, October 19, 1976, p. 1. Kwitny's report includes two quotes from De Angelis. These rare direct glimpses of De Angelis demonstrate that Joe Pesci would make the best candidate for his film biography: "You're going to get -- I'm not threatening you, you understand me, but you're going to get -- I'm not going to do anything to you, but you're going to get what you deserve out

of life."; and, "I don't care what you put in your paper, but if you ever publish anything about me and it's untrue, I'll cut your [obscenity] throat from ear to ear. You can record this. I did 15 years in prison, and nobody's going to hurt me again."

(21) "De Angelis Will Return To Prison for Latest Fraud," *Wall Street Journal*, August 18, 1993, p. 2.

(22) Interview with Kerry Thornley, *Steamshovel Press #5*, Summer 1992.

(23) Bain, Donald, *The Control of Candy Jones*, Playboy Press, 1976.

(24) O'Brien, Cathy with Phillips, Mark, *Trance-Formation of America*, Las Vegas: Reality Marketing, 1995.

(25) Keith, Jim, *OKBomb!*, Lilburn, Georgia: IllumiNet, 1996, p. 195.

The progress of the Biometric Consortium, a group that "has been meeting one to two times per year to provide a forum for information exchange on biometric-based personal identification/authentication technology among the Government, industry, and academia", can be checked on the World Wide Web at **www.vitro.bloomington.in.us:8080/ ~ BC/**

(26) Lange, Larry, "Treading Fine Line Between Man and Machine," *Electronic Engineering Times,* February 10, 1997, p. 24.

(27) About 1957, Lee Israel's biography, *Kilgallen* (Dell, 1979) records only that Dorothy Kilgallen became an ardent fan of Lenny Bruce that year. Bruce, in turn, gave homage to Reich with references in his samizdat of the time, *Stamp Help Out!*

(28) Reich's earlier work on the bio-electric nature of sexuality probably informed some of the development of RHIC/EDOM and other forms of mind control technology. Reich gathered data on body responses to "specific emotional and mechanical stimuli" using an oscilloscope. He describes this research, along with electrophotographic reproductions, in his 1945 book, *The Bioelectrical Investigation of Sexuality and Anxiety.* Unfortunately, the book remains out of print and difficult to locate, like much of Reich's work, although the *Flatland* book service, POB 2420, Dept. WWC, Fort Bragg, CA 95437, remains a good source. Martin Cannon, in his seminal but unpublished work on alien abduction and mind control called *The Controllers*, comments that "one of the few pages released on MKULTRA subproject 119 concerns 'a critical review of the literature and scientific developments related to the recording, analysis and interpretation of bioelectric

signals from the human organism, and activation of human behavior by remote means."

(29) Rothberg did not respond to written inquiries about this document.

(30) Russell, Richard, *The Man Who Knew Too Much*, New York: Carroll & Graf, 1992, pp. 676-678.

"Damon Runyon, Jr. Is Killed In Plunge," *New York Times*, April 15, 1968.

THE FOREIGN SERVICE
OF THE
UNITED STATES OF AMERICA
American Embassy
Paris 8, France

Date: October 12, 1960

To: Director, FBI (105-82555)

From: Legat, Paris (105-10671)

Subject: LEE HARVEY OSWALD
 INTERNAL SECURITY - R

SECRET

Classified by 9403 MM hpc
Declassify on: OADR

Re Paris letter 9/27/60.

THE FOREIGN SERVICE
OF THE
UNITED STATES OF AMERICA
American Embassy
Paris 8, France

Date: October 12, 1960

To: Director, FBI (105-82555)

From: Legat, Paris (105-10671)

Subject: LEE HARVEY OSWALD
 INTERNAL SECURITY - R

Re Paris letter 9/27/60.

The Swiss Federal Police furnished the following report on October 1, 1960 (S)(u)

The investigation at the "Albert Schweitzer College" located at Churwalden, Switzerland, revealed that OSWALD actually had announced his proposed attendance at this school for the course beginning in the Fall of 1959. Inquiry at the college revealed that he has not arrived there up to the present time. He had originally written a letter from Moscow indicating his intention to attend there. A letter which was addressed to him at this address by his mother was returned to her since his whereabouts are unknown to the college. The Swiss Federal Police advised that it is unlikely that he would have attended the course under a different name. The Swiss Federal Police advised that this same information was given on October 2, 1960, and that it is possible that the school may now receive further correspondence from OSWALD. At the present time, there is no record of a person possibly identical with the subject who is registered for the courses beginning October 2. (S)(u)

The Swiss Federal Police advised that if further information comes to the attention of the Albert Schweitzer College, they will be advised and they in turn will advise

RUC
2 - Bureau
1 - Paris
NVP:mas
(3)

REC.41 105-20.555 — 10

EX-109 0 OCT 18 1960

5 00CT 20 1950

SECRET

In 1995, the Assassinations Records Review Board forced the FBI to release this document concerning Oswald's application to the Albert Schweitzer College in Switzerland. This document had only been available previously in a redacted form. See chapter 8, "The Plan To Go To Switzerland."

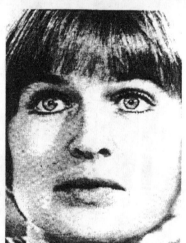

Top: A KGB surveillance photo of Marina in Minsk, circa 1961. Bottom: Marina Oswald in 1963.

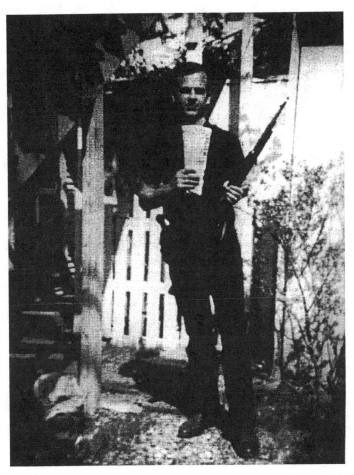

Lee Harvey Oswald holding a rifle, a Marxist newspaper in his back yard.

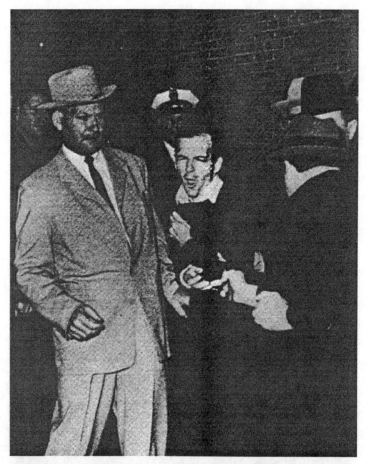

Jack Ruby shoots Oswald in the stomach as he is being moved from the Dallas jail. Lawrence claims that Ruby was one of the three R.H.I.C.-E.D.O.M. mindcontrol victims discussed in *Were We Controlled?*

CONTENTS

WERE WE CONTROLLED?

1.

Were We Controlled?

Let us note for future generations that the whispered rumors about the assassination of John F. Kennedy and the printed news stories differed greatly. This book concerns itself with one of the most significant of these rumors, one which, at the very least, deserves careful study.

In the Dallas rumors, as in all rumors, there is a kernel of truth to be found in some. And in those which are vicious and cruel, there is a momentary reflection of all of us . . . at our gossiping worst.

In a sense, our reflected image—how we really are—is part of the reason for what happened. Ru-

9

mors and their evaluation, therefore, have a place in the over-all historical analysis that our grandchildren will some day make of the tragedy.

This account, by its very form, is a most unusual document. Taking the bare threads of a rumor, we will weigh on the scholars' scale the reputations, names and actions of real people and corporations who, before this report, have not been associated in the public's mind with the assassination.

This is a very delicate matter . . . and if you read further, it must be with the understanding on your part that you completely comprehend the fact that scientific speculation is necessary to decide whether the rumor is unfounded or not. Much as a major intelligence agency may explore a hundred hypothetical "possibles" (however bizarre) to find the one "definite" that fits with the facts . . . so *we* are going to travel down one hypothetical pathway.

We are therefore requesting that you read further *only* as if you were a trusted, discreet, cool-headed member of an intelligence group. You are following a hypothetical proposal dealing with the most sensitive kind of speculation about a plot which includes perfectly respectable everyday people who may be in no way guilty of any kind of criminal act!

At the very least . . . you are in for an exercise in deduction. You will be given in the pages that follow . . . certain information about Behavior Control that you have *never been given before!*

Were We Controlled?

Many of the experts in the field believe you are not ready for this briefing. We disagree. You will learn things about the assassination, startling things —revealed by three years of secret research—that you will find breathtaking! We are not speaking about the endless analyses of the trajectory of the bullets or how many were fired. We feel there is a certain futile sadness about the well intentioned efforts that are still being made in that direction. Much of the discussion of whether the bullets entered from the front or the back of the President's body is pointless since the passing of time has so clouded the facts that exact evaluation is next to impossible.

Are we never going to be allowed to heal the wounds within all of us that were made by the shock of losing John F. Kennedy? Warmed over second guessing about clinical details of wounds only serve to haunt and horrify—not to prove a case.

As for Mrs. Kennedy's heroic, torturous hours, you will read no more of them in this book. Neither for the sake of book sales nor for the sake of legal pertinence do we believe that they have any tasteful place in an analysis of what happened. It is well past the time when the curtain of privacy should allow her some peace.

Time and events have shrunk the chance we had to accurately count the bullets and probe the witnesses' minds but there are still big questions that can be answered . . .

Were We Controlled?

We believe the real challenge is to those intelligence experts all over the world who were left a mocking challenge as Jack Ruby's bullet found its target.

After thorough study, it is my conclusion, the good men who labored on the Warren Commission Report did a yeoman job. This, I believe, despite the fact that they did not produce a document that eliminated all doubts.

On June 30, 1966, Chief Justice Warren made the following statement to James Feron of *The New York Times*:

> "We wrote our report—it was the best we could do after ten months of intensive research —and we delivered to the National Archives every document that we had, every working paper and the differences of opinion in staff and ourselves as we went along.
>
> "It would be easy for anyone who wanted to find some adverse conclusion to find differences
>
> of opinion, but that was our conclusion, it was unanimous, it was the best work we could do in ten months.
>
> "On that Commission were representatives, and very responsible representatives, of both parties in our Government and all we can say is that the report was the best effort we could possibly make."

12

Were We Controlled?

Law enforcement agencies did more than capable work on many levels. I firmly believe that this is so after applying a series of unique yardsticks to the puzzle.

Why then the flaws in their case?

Could it be that the crime was planned and carried out using new procedures and tools designed to withstand *exactly* the kind of scrutiny applied to it? Were extraordinary, ultra-sophisticated methods utilized for a solution-proof crime?

Is it possible that truly clever criminal minds actually were able to obliterate the visible facts and thereby limit the judicial vision of men like those who contributed to the Warren Report?

We humans are partly an intuitive space animal. It is not possible to destroy the feeling that lies sometimes mysteriously within us—a feeling that *something* happened that we can neither describe nor classify. This is true of what happened in Dallas . . . and in this book . . . for the first time . . . we will move in a new direction behind the surface facts of the assassination . . . and reach briefly into the dark in an unprecedented kind of search for the truth!

When we decided to compile the "rumors" about Dallas for later evaluation, we frankly did not expect they would range quite as far from normal paths as they did.

13

Were We Controlled?

We will not insult your intelligence by wasting type on the rumors about Those High Up in Washington who were behind it all.

The Havana, Moscow, Peking origination—we have carefully considered and have rejected. Oswald's involvement for whatever psychological or political reasons with these three forces, we have decided, was not the key raison d'être of the assassination. Amazingly enough, although we went into our investigation with, we thought, rather cynical world-weary eyes, used to almost everything, a few of the rumors did catch us off guard!

We must tell you about them before we get down to serious business.

We were told quite flatly that there was in existence a report that named three men who concocted a diabolical plot to kill JFK. It was supposed to be fifty-eight pages in length and was circulating in Chicago. We thought that this was a slim lead, but decided that we must find it and read it.

In view of the fact that we devoted most of our waking hours for three years to this investigation, perhaps it isn't surprising that we did indeed find that "report"!

Its author, David M. Warren, refers to it as an "explosive documentary novel." In the early pages appears the claim that it "blows the lid off the secrecy surrounding the facts of Kennedy's assassination."

14

Mr. Warren begins his strange story with these words: "Contrary to the findings of the FBI and the Presidential Investigating Commission, there was a plot behind the senseless slaying of President John F. Kennedy . . . The killing was not the work of a lone assassin as most people have been led to believe . . . A private investigating firm located in New York City have in their possession documented evidence which backs up this charge."

Mr. Warren's cast of characters includes two directors of the plot and a third person who was the key man in the plot. The fatal shot was fired by a marksman other than Lee Oswald, and Oswald was merely a dupe used by the key man.

This odd document ends with a strange statement. In the beginning of his narrative, Warren writes, "Part of the mass of evidence unearthed by the private investigators included a diary, a small black book that contained, in shorthand, a detailed account of the plot to assassinate the President."

At the very end, after hinting the federal government may be ignoring the truth and embracing an "un-Godly philosophy," he concludes with:

". . . in the meantime, this writer's beliefs are inclined to be in rapport with the revelations which are contained in the little black diary.

"And if there is anybody, or any govern-

mental agency with evidence in their possession which will refute the contents of the diary, let them come forward and present their case.

"The world waits."

In the thought that perhaps we did not quite comprehend what Mr. Warren meant when he labeled his work a "documentary novel" we went back to the dictionary for these definitions.

"Novel"—story with characters and a plot; fictional prose.

"Documentary"—something that proves by documents.

Evidently Mr. Warren believes the "little black diary" is a document that proves his prose.

We concluded that Mr. Warren's fascinating account was not the one rumor we would choose to do in-depth surgery on but we made a note to ourselves to remember to place in *this* book the address that would enable authorities curious about this little document to peruse it to their heart's content. May we suggest they visit 2715 North Pulaski Road, Chicago? (This address was valid in 1965).

In August of 1964, there appeared in *The New York Times* an arresting advertisement that was missed by many eyes because it was rather small in size and crowded with small type.

Before the paper was on the stands, we were

alerted to obtain it for study. The headline in the copy read:

WAS THE

KENNEDY ASSASSINATION

ENGINEERED?

A printed report was offered (for about the cost of printing and postage) by a group in Washington D. C. This and other material published by it under the banner of L'Avant Garde Press suggested that "Psychic Displacement" was the instrument of both the assassination and other events which have occurred since October of 1962.

After subjecting L'Avant Garde's output to close scrutiny, we came to a personal conclusion that it was sincerely presented, but to be polite about it, very much on the improbable side. We simply did not find any relevance in it to the reality of the situation we were investigating.

(L'Avant Garde and its chief researcher, William R. Smith, have subsequently [1966] offered to a private mailing list a 240 page thesis on the doings in Dallas entitled "Assassination by Consensus." This mimeographed report makes a more determined effort to explain what is meant by "psychic displacement." Despite some incredibly wild conclusions . . . this offering *does* bring out one or two minor points that so far eluded Lane, Epstein, Sau-

17

vage et al. Smith did considerable research and perhaps serious students of Dallas should make an effort to add his book to their files.)

The next rumor that was researched as a "possible" was the "warning" rumor.

This one was particularly fascinating!

We were told that a magazine published in August of 1961 had printed an open letter to JFK which bore the heading,

"ATTENTION PRESIDENT KENNEDY!
Read the story MURDER IN TEXAS!"

The author of the open letter was a prominent American writer, William Bradford Huie. It was a factual account of some dark doings of an alleged political assassin residing in Mexico.

There were, in this tightly written account, some unfortunate and tasteless references to a certain figure now prominent in Washington which preclude my quoting the piece in detail. I do not mean this in any way as a criticism of Mr. Huie's research or intent. Indeed it was a bravely written crusading piece which cried for justice in a situation where it seemed to be thwarted. It was a plea to Kennedy to extradite the purported assassin from Mexico by using the power of the White House.

Although the article itself did not relate to what actually did later happen in Texas, the irony of the title is undeniable.

18

Next, we came to a rumor that was so hush-hush that it barely surfaced often enough to be grasped. This was one a few "old pros" in the intelligence field kicked around in high circles . . . but not very often because it was quite complicated and terribly involved. It was not something you could speculate over while having a cocktail after work. It demanded hours just to comprehend the skeleton of the rumor . . . and was therefore not often passed from one to another.

We originally heard of it as "The Wall Street Rumor" . . . and we have lived with it so long now that we refer to it simply as The Rumor. And that is what it is . . . terrifyingly, incredibly . . . if you will . . . *completely* unbelievable! It is though a tauntingly alive rumor that we simply could not turn our back on.

We devoted almost three years to tracking down facts and analyzing them to prove it out or discount it.

This book is the result.

2.

The Structure of a Rumor

At a distance they looked to the patrons of the crowded Wall Street restaurant like simply another pair of stock brokers taking their Friday afternoon martini-and-lunch.

Eavesdrop for a second and listen to their conversation that Friday afternoon of just a few years ago. It was a Friday that saw the market rock to its foundations.

The taller man leaned over his drink and addressed the younger man in tones that betrayed his great strain.

"Not since '29 has there been anything like it! . . . and don't tell *me* that it's all just accidental!"

The younger man reddened as if the Stock Exchange were something close to his flesh and blood. "Of course, it's not an accident . . . it's the result of sloppy manipulation. The worst kind of fraud. It just finally blew the top off the whole thing. Nobody expected it. Certainly none of us *wanted* it!"

But the older man persisted in making his violent point. "*Somebody* wanted it! It couldn't be an accident. Somebody was plunging heavily short. Somebody made a *half billion dollars* and they *knew* what they were doing! It was *planned* to dump the market today. It was planned, I tell you! American Express might go under . . . Two of the biggest houses flattened. When you can make all that happen in *one* day and when you *know* it's going to happen, you can sell short and you can *clean up!*"

The younger man nodded dubiously, humoring him.

"Look . . . *don't doubt me!* What more could anyone do to knock the props out from under the market than they've done today. What else could they pull to get a deliberate drop?"

The younger man shrugged, "Nothing but shoot the President!"

It was exactly at this point, that the waiter deposited two martinis nervously on their table, spilling part of one.

"Excuse me, gentlemen—but you probably haven't heard the news. It just came over the radio in the kitchen. They've shot President Kennedy!"

There was a stunned pause and then the younger man whistled softly.

The older man reached uncertainly for his drink —suddenly pale.

3.

The Rumor

A small group of hard-as-steel international criminals (with German-Argentine intellectual and scientific backgrounds) carefully calculated that:

> The coincidence of the assassination of a President of the United States . . . and the simultaneous scandalizing and collapse of the commodities market . . . would rapidly *drive the stock market down at least 30 points!*
>
> Having advance knowledge of this event . . . the group would *sell short* on a heavily financed scale . . . and a profit of perhaps a *half-billion dollars* would be divided amongst its members!

23

Were We Controlled?

Victims of the advanced techniques of behavior control—R.H.I.C. and E.D.O.M.—Lee Oswald, Jack Ruby and key figures in the commodities market were used, without their knowledge, as the human tools by which the end result would be achieved. And thus . . . more money was to be accrued from one single crime than ever before in history!

This, in effect, is The Rumor. The job of this book is to ascertain whether the facts support it!

In the course of examining the structure of The Rumor—we will learn just *how far advanced* the art of Behavior Control is today. Is it a tool, a weapon, or at the very worst, a scientific nightmare that threatens our freedom and security?

4.

The Tools: R.H.I.C. and E.D.O.M.

The public is generally aware of the time lag between the development of advanced scientific weapons of defense and their announcement. Secrecy makes sense on the checker-board of international power politics. The "Manhattan Project" comes all too vividly to mind in this context.

A case in point we would like to recall is an incident which disturbed us many years ago. It provides a fair warning for the reader that *no matter how fantastic* the tools of R.H.I.C. and E.D.O.M. may seem as we describe them to you, they will be *no more fantastic* than the facts in the following incident seemed at the time.

Were We Controlled?

The time was November of 1940 . . . when the clouds of a major world war were heavy in the sky and Hitler was the inevitable enemy to be defeated.

That year, a man named Fred Allhoff felt (even as this author does today about Behavior Control) that we were going to have the very foundations of our existence shaken by the announcement of a scientific advance that was being held back from us. Under the guise of fiction entitled "Lightning in the Night" in *Liberty* magazine of November 16th of that year, Allhoff broke through that time-lag barrier and his readers were given the same kind of *advance* information you will find in this book.

Wrote Allhoff:

> ". . . The President of the United States resumed, 'As you gentlemen have suggested, the development of atomic energy will mean a revolutionary change in the life of every human being now on earth. It can be an overwhelming force for good or for evil.' . . . later . . . 'We saw its potentialities as a weapon of war, but even more clearly as an unlimited source of heat, of light, of power for peaceful production and transportation . . .' . . . and further on . . . 'Our goal, I must repeat, was the creation of a new, rich, peaceful world for all. To reach that goal, we needed to unlock atomic energy before you (Hitler) could do so; to produce tons of

pure uranium-235 before you could do so; and
then to master the world through the threat of
its irresistible destructive force—a force we
hoped would never have to be put to use . . .
a weapon that must inevitably overwhelm and
subdue any nation on earth.' "

Mr. Allhoff revealed the major scientific advance
of his time *years* before the scientific black-out was
lifted. The seeds of the A-bomb were there *then*
when Allhoff warned about it. E.D.O.M. and R.H.
I.C. are here *now* but you simply aren't being told!

So much for this incident which forecast The
Atomic Age.

On another front—the battle of men's minds—
there is an equally significant time-lag today.

Behavior Control has progressed far beyond your
most fearful dreams . . . and certainly beyond the
printed information available to you.

There are two particularly dreadful procedures
which have been developed. Those working and
playing with them secretly call them R.H.I.C. and
E.D.O.M.—Radio-Hypnotic Intracerebral Control
and Electronic Dissolution of Memory.

Although the general public is still in the dark
about the progress being made (and the implications
of such progress upon the freedoms of man), the
United Nations is quite aware of it. The Interna-
tional Brain Research Organization—IBRO—was

formed by UNESCO and held its first formal meeting in Paris in October of 1960. Present-day work in thought control is undoubtedly under UN observation.

How has this field evolved? Since the late nineteenth century, when Fritsch and Hitzig began the epoch of physiological research into cerebral stimulation, there has been orderly and important progress. In the last decade, scientists admit that the invention of new techniques has so increased that, as Professor Stanley Cobb of Harvard puts it, "One is overwhelmed!" Topflight U. S. brain expert Daniel E. Sheer states that "Progress has continued at such an accelerated pace that new data quickly becomes superseded by newer data."

One of the first milestones in this research came in 1903 when Vladimir M. Bekhterev published, in Russia, a seven volume report called "Foundations of the Theory of the Functions of the Brain." Bekhterev, an acknowledged founder of the Russian school of neurology, presented some of the earliest important conclusions on methods of stimulation of the brain. He called his procedures the study of *reflexology.*

It is Bekhterev's work rather than the more famous Pavlov theories which laid the groundwork for the modern work on behaviorism done in Russia.

This information is important to keep in mind later when we study the activities in Minsk as Lee

28

The Tools: R.H.I.C. and E.D.O.M.

Harvey Oswald lay under the surgeon's knife when he lived in that city.

Bekhterev's work led to much more sophisticated advances made under the guidance of John B. Watson, who was the first to put forth the cause of behaviorism in America.

The groundwork for the incredibly sophisticated field of radio control of the brain was laid as early as 1934 when E. L. Chaffee and R. U. Light published a paper called "A Method for the Remote Control of Electrical Stimulation of the Nervous System."

Others who pioneered in the use of radio and induction for such control include Loucke (1934), Clark and Ward (1937), Fender (1937), Harris (1946-47), Gengerelli and Kallejian (1950), Mauro (1950), Verseano and French (1953), Greer and Riggle (1957), and most important of all, Jose M. R. Delgado in Madrid and New Haven.

The advanced equipment of the American Electronics Laboratory has enabled modern day experimenters to reach new heights in this field. Their stimulator and radio frequency isolation units are widely and successfully employed in research. This work is described in detail in "Distant Evoked Responses to Single-Pulse Stimulation" by Bickford, McDonald, Dodge and Svien (1961).

Since a number of men involved in the machinations of Tino De Angelis and the plot to assassinate

Were We Controlled?

John F. Kennedy may have been *unknowingly* controlled by the use of R.H.I.C. and E.D.O.M., we must do our homework on the nature of these procedures. In order to understand R.H.I.C., first of all we must study a simpler (and yet related) form of control, primitive by comparison. This would be Intracerebral Electrical Stimulation or as it is referred to in non-technical nickname, E.S.B.—simply *electrical* stimulation of the *brain*.

The progress in this field of research and application lies like the proverbial iceberg . . . mostly below the surface. R.H.I.C. is a top secret toy of the "controllers"—E.S.B. is not. It belongs to responsible science. In the past year, we have been allowed a brief glimpse past the curtain of secrecy in this area.

In *The New York Times* of Monday, May 17, 1965, there appeared a front-page story with two photographs headlined, "Matador with a Radio Stops Wired Bull."

This story graphically detailed the fascinating experiments conducted by Dr. Jose M. R. Delgado in his laboratories at Yale University's School of Medicine and certain "field" work in Cordova, Spain. These experiments were explained by *Times* writer John A. Osmundsen in these words:

"... Afternoon sunlight poured over the high wooden barriers into the ring as the brave bull

30

bore down on the unarmed 'matador'—a scientist who had never faced a fighting bull.

"But the charging animal's horn never reached the man behind the heavy red cape. Moments before that could happen, Dr. Jose M. R. Delgado, the scientist, pressed a button on a small radio transmitter in his hand, and the bull braked to a halt.

"Then, he pressed another button on the transmitter and the bull obediently turned to the right and trotted away.

"The bull was obeying commands from his brain that were being called forth by electrical stimulation—by the radio signals—of certain regions in which fine wire electrodes had been painlessly implanted the day before.

"The experiment, conducted *last year* [italics ours] in Cordova, Spain, . . . was probably the most spectacular demonstration ever performed of the deliberate modification of animal behavior through external control of the brain.

". . . he has been able to 'play' monkeys and cats 'like little electronic toys' that yawn, hide, fight and go to sleep on command."

The story continued:

"Experiments have been conducted on human beings by Dr. Delgado and other scientists

primarily during the treatment of certain types of epilepsy . . .

"He has been working in this field for more than 15 years. Techniques that he and other scientists have recently developed have been refined to the point where, he believes, a turning point has been reached in the study of the mind."

5.

He Is Not Alone . . .

Dr. Delgado is by no means alone in his field of work . . . but he is a giant in that field. A man of great charm, brilliant intellect . . . and a certain air of mystery.

Those who are allowed into the Delgado first floor laboratories in the handsome Yale building in New Haven experience quite an adventure—if they get the permission (rarely granted) to visit the area where the Macaque Mulata monkeys, used by the doctor in his experiments, are kept.

The first-time visitor to those well-lighted cage areas will be shaken by the sight that awaits him.

It is one thing to *read* of the experiments, in the neat type of medical reports, and quite another to *see* the monkeys close up with the tiny metal antennae implanted in the top of their skulls. They are lively enough, and well cared for. They are normal monkeys until the buttons on a small nearby hand transmitter which resembles a walkie talkie are pressed. And then? . . .

Then—suddenly—the year 2000—is *now*!

A vital question that would link E.S.B. research at Yale with advanced R.H.I.C. was put to Delgado bluntly. Had the control of the brain been attempted on either humans or animals using radio waves *alone* . . . with no implantation in the skull? A guarded look came into the scientist's eyes. "There had been experiments . . ." That was as much as he would say.

On May 6, 1965, in the course of the James Arthur lecture on "The Evolution of the Human Brain" at the American Museum of Natural History in New York, Dr. Delgado left his audience with this thought: "Science has developed a new electrical methodology for the study and control of cerebral function in animals and humans."

In his paper published in Exerpta Medica International Congress No. 87 (Tokyo 1965), Professor Delgado in reference to chronic radio-stimulation of the brain has this to say in his conclusions: "Radio-stimulations of the brain were applied for five sec-

onds once a minute, more than 20,000 times during fourteen days, with reliable results and without disturbances of thresholds, spontaneous electrical activity, or morphology of neurons. These facts suggest that programmed stimulations of the brain may be carried out perhaps indefinitely."

Remember those words, *programmed stimulations* and *perhaps* indefinitely. As our journey through the structure of The Rumor moves into strange byways, they will reassure you we are not dealing here with science-fiction.

All of this takes us a trifle past treating epileptic symptoms directly on the road that leads to R.H.I.C.

The taunting, mocking question that constantly arises when evaluating Dr. Delgado's public announcement of his work is . . . how recent *are* these developments? Has he brought us up-to-date? Wide-eyed, he will tell you he "can't imagine" how E.S.B. could be used as a tool in brain-washing during wartime. But perusal of his work divulges the fact that his efforts have been quietly subsidized by grants from the Office of Naval Research.

Perhaps there is a considerable gap of time between what Dr. Delgado and Yale announce today . . . and what progress they have actually made. An amusing sidelight pointing toward this possibility came when a gentle bit of investigative scrutiny was applied to the good doctor's statements.

In May, of 1965, John Osmundsen's excellent

Were We Controlled?

New York Times article refers to Delgado's flamboyant demonstration with the bull as having taken place "last year" (1964) in Cordova, Spain.

Although Dr. Delgado modestly avoids emphasizing the Spain episode in conversations at Yale, he nevertheless has a series of large photographic blowups of himself and the bull on the wall behind him. If you gaze at the pictures of the experiments on the wall and Dr. Delgado at the desk in 1965, you must notice that in Spain, Dr. Delgado was an athletic and striking *black*-haired figure of a man—who might even have stopped the bull bravely with a sword instead of a radio transmitter. Across the desk from you, supposedly a matter of "months" later, sits the distinguished, *gray*-haired scientist of the moment.

Why this unseeming skepticism? Why this cynical probing and doubting as to whether we are being handed ancient history instead of the real news about E.S.B.—so vital to the understanding of R.H.I.C.?

Let us compare the doctor's announcements with a paper offered by another equally well-qualified man of science. We refer to the late L. L. Vasiliev, Professor of Physiology in the University of Leningrad. We quote from "Critical Evaluation of the Hypnogenic Method of the Results Obtained by its Application (Improved Version of the Hypnogenic Method from Experiments in Mental Suggestion)."

36

It should be noted that we move a little further in the direction of R.H.I.C. . . . as hypnotism is introduced into the procedure.

Here are excerpts: "As a control of the subject's condition when she was outside the laboratory in another set of experiments, a radio set-up was used. . . . Not many experiments of this sort were carried out, but the results obtained indicate that the method of using radio signals substantially enhances the experimental possibilities."

The date of this paper and for these experiments was 1934—thirty-one years before Yale's "news" announcement.

In another part of the paper, Professor Vasiliev reports: "Tomashevsky [I. F. Tomashevsky, famed Russian physiologist] carried out the first experiment with this subject at a distance of one or two rooms and under conditions where the participant would not know or suspect that she would be experimented with. In other cases, the sender was not in the same house and someone else observed the subject's behavior. Subsequent experiments at considerable distances were successful . . . One such experiment was carried out in a park at a distance . . . Mental suggestion to go to sleep was complied with within a minute."

Here over thirty years ago was primitive R.H.I.C. in operation. It is inconceivable that the fraternity of science has not exchanged information, achieved

similar breakthroughs and progressed far past the announced point in this field.

What then is R.H.I.C.? It is the ultra sophisticated application of post-hypnotic-suggestion *triggered at will* by radio transmission. It is a recurring hypnotic state, re-induced automatically at intervals by the same radio control. An individual is placed under hypnosis. This can be done either with his knowledge—or *without* it by use of narco-hypnosis, which can be brought into play under many guises. He is then programmed to perform certain actions and maintain certain attitudes upon radio signal. The signal is practiced while he is under hypnosis to "teach" him how to respond. Certain behavior can therefore be "played" (to use Dr. Delgado's term) over a period of days or even months. Re-introduction can be instituted by the same procedure to continue the control for an *unlimited time!* That, in essence, is R.H.I.C.

Sound a little improbable?

Let us consider, for example, this "radio" that induces the behavior control. On May 22, 1963, there was a meeting in the office of Professor Zinoviev at the Ministry of Higher and Secondary Specialized Education of the USSR. Professor Artemov from the First Moscow Institute of Foreign Languages let a little tidbit drop. Someone in the group present (fifteen men and one woman—one of whom provided our "ears") challenged Professor Artemov

to explain his allusions to a new "mental work machine." He did so . . . and vigorously. In the "not distant future," he foresaw transistorized machines about the size of today's transistorized radios that would encourage the creativity of the individual . . . help the individual "make full use" of all his available brain cells and mental energy. Artemov described the machine.

Visibly startled, the group was quick to respond to the announcement. Artemov was asked what success the Soviet scientists have had in the construction of these "mental work machines."

He stated that early models had been desk-top size but they were now portable! They were *actually in use!*

The discussion zerod in a few minutes later on microwaves.

Professor Artemov said that Soviet scientists are trying to control these radio waves and to use them to achieve specific objectives.

If you are skeptical of the possibility that electrical impulses of *any* kind can influence human behavior, consider these revelations from a report titled "The Effect of Electricity on the Human Body" by the World Meteorological Organization.

> Behavior: Traffic accidents rise 70% on days of high electrical charging in the atmosphere due to weather; indus-

trial accidents jump 20% over or-
dinary days.

Pain: Chronically ill patients complain of
pain twice as much. Amputees
double their complaints.

This report reveals what appear to be effects of an
uncontrolled naturally occurring form of E.S.B.

How exact an act can be controlled by E.S.B.?
The chilling answer is hidden in a long and excel-
lently researched report by Neal E. Miller entitled,
"Learning and Performance Motivated by Direct
Stimulation of the Brain." He says, "I have watched
electrical stimulation cause a cat to lower his head
and lap water from a dish, but when the dish was
moved to one side, the cat lowered his head and
licked the floor."

Intensive study confirming the effect of electro-
magnetic fields and their influence on human beings
was carried out by Professors Howard Friedman and
Robert O. Becker of the State University of New
York in Syracuse and Professor Charles H. Bach-
man of Syracuse University Physics Department.
28,642 patients in seven VA hospitals provided the
subjects for this study.

It is a long leap from published reports of this
kind to the secretly developed, highly sophisticated
radio-hypnotic control that we call R.H.I.C.—but it

is the information gap in between that we are probing.

In considering Vasiliev, we simply point out that development of R.H.I.C.-type procedures began successfully over thirty years ago. Artemov disclosures are singled out because he revealed information about some of Russia's recent progress in the field of control. But R.H.I.C. itself apparently is *not* Russian or American in origin.

Professor Delgado's publicly announced work in the general press has linked itself with large and small animals. However, within the scientific brotherhood it has leaked out that experiments more pertinent to our road of inquiry were carried out. In a report to the 29th Educational Conference, Dr. Delgado had this to say, "Fortunately, experimental data on human E.S.B. have also begun to accumulate from patients in whom it was necessary, for therapeutical purpose, to explore the cerebral cortex or to implant some very fine electrodes inside the brain. Some of these patients have undergone testing for weeks and months, and lead a nearly normal life while ten, twenty or even more, fine wires are present in different cerebral areas and ready for stimulations from outside the scalp."

He adds: "In our studies, spontaneous conversations of the patients with the therapist were tape recorded. . . . from time to time, different intracerebral points were electrically stimulated . . . Later,

the entire conversations were transcribed and their ideological and emotional content were analyzed by independent investigators to determine possible changes induced by E.S.B. and to evaluate the statistical significance. Results demonstrated that both subtle and spectacular changes in mental activity can be induced by E.S.B."

Admitting in this same report the possible existence of . . . to quote him ". . . incipient uneasiness on the part of the audience who may wonder if we could be surrounded by radio waves which secretly direct our thoughts and desires," he points out the utter complexity of the spatio-temporal integration of the brain's nerve cells would preclude robot-like control. Indeed, Professor Delgado is correct. E.S.B.'s manipulation of behavior is limited, because it does not harness the will. R.H.I.C. *does* harness the will, through the use of post-hypnotic suggestion—and therein lies the danger!

The hypnotically suggested course of action . . . triggered by E.S.B. . . . equals R.H.I.C., the ultrasophisticated, virtually unlimited technique for Behavior Control. Has Delgado heard rumors of experimentation in this direction?

One gathers from talking with Delgado that he realizes that he stands with a very few others on a lonely shore gazing out on a just-discovered ocean. What lies beyond the horizon, you feel, gives him far more cause for somber reflection than he is will-

ing to admit to. What of the others who stand beside him . . . men who have arrived independently and over whom he has no control? He many well have discovered new meanings for the word fear.

The social implications of E.S.B. and its effect on behavior are dwelt upon at length in Delgado's papers. Mostly, however, they concern a social circle that is composed of the Rhesus Macaque. When he speaks of E.S.B.'s effect on his monkeys' aggressiveness, their inhibitions, their community social behavior . . . one often gets the feeling that he is thinking way past the Simian World.

One particularly interesting remark appears on page 126 of *Innovation and Experiment in Modern Education*. "After several days, the monkey had learned to press the magic lever which controlled the boss' activity, proving that a monkey may be educated to *direct the behavior* of a *powerful dictator* by using artificial instrumental means."

Odd words . . . in a report on E.S.B. and monkeys . . . "powerful dictator" . . . very odd. There are overtones of R.H.I.C. throughout all the reports of Behavior Control research. It is always there in the shadows.

Lee Harvey Oswald, at the time of his arrival in Soviet Union, 1959.

6.

The Time Sense

R.H.I.C. is the tool for individual control of human behavior. No group callous enough to play with such a toy could resist the challenge to try to reach the obvious extension of this kind of experimentation and influence important events utilizing radio waves.

Is there any evidence that they have succeeded? Since such control would have made possible certain of the seemingly impossible events that occurred in Dallas and New York, we must give some consideration to this effort.

To our index of terms, add one more—E.D.O.M. E.D.O.M. refers to Electronic Dissolution of Memory.

Were We Controlled?

If that term causes you to sigh weakly and lean backward toward your shelf of science-fiction, we refer you to the Berkeley Meeting of the American Association for the Advancement of Science in 1965. There, E.D.O.M. surfaced for just long enough to be noticed.

At that meeting, Professor J. Anthony Deutsch of New York University probably didn't realize he provided pioneer public substantiation of an important segment of the E.D.O.M. theory . . . but he did.

Before we consider what his speech implied, let us define roughly what E.D.O.M. *is!*

The sub-rosa work in this field, by the same men who developed R.H.I.C., is fraught with implication of space age weaponry.

To put it quite simply, E.D.O.M. enables man to juggle with other men's sense of time. It provides illusionary distortion of memory that destroys time orientation. For the execution of a crime (like the one in Dallas) or the execution of an organized warfare tactic, E.D.O.M. offers unbelievable new powers!

How does it work? Well, let's do a bit of homework.

The basis of stored memory is the presence of a neutral transmitter substance, acetylcholine, at a synapse (which separates one nerve cell from another). E.D.O.M., through the use of radio-waves,

and ultra-sonic signal tones suddenly builds up an excess of the transmitter substance so that it cannot transfer excitation from one cell to another. It in effect blocks memory of the moment, which is our feeling of momentary time. It *stops time*—for as long as it is placed in use! E.D.O.M. could therefore be used for—let us say—a period of several minutes to make someone skip over those minutes without being aware of the passage of time.

Nice toy, eh? We will see how it may have been brought into play a little later on.

Professor Deutsch in addressing the Berkeley Meeting of the AAAS described his work in this field, apparently with no awareness of its connection to E.D.O.M.

In a report entitled, "Anti-cholinesterase and Dissolution of Memory," he notes: "Too much transmitter, like too many cars on a highway, causes a jam and so stops transmission. . . . An excess of acetylcholine stops transmission across a synapse . . ."

In his report, Dr. Deutsch describes the loss of memory due to the administration of a drug which raises acetylcholine levels . . . but according to The Rumor, the developers of E.D.O.M. have managed to go a step further and stimulate the production of acetylcholine not by drugs but by radio waves.

Additional information which is interesting in connection with the concept of E.D.O.M. appears in

a paper titled "Micro-electrode Analysis of Stimulation Effects on a Complex Synaptic Network" by Vahe E. Amassian and Harry D. Patton, published in 1961.

Professor Amassian works in physiology at the Professor Albert Einstein College of Medicine at Yeshiva University in New York. He describes the ". . . movement of ions across neuronal membranes (on a complex synaptic network) under the action of the electrical field created by the stimulus. This may lead to either local excitation or inhibition of neurons."

Still other men of science have published reports that can be related to the theory of E.D.O.M.

In *Implications for the Neurological Sciences,* Professor Herbert J. Jasper, Professor of Experimental Neurology at the Montreal Neurological Institute, states: ". . . Amassian and Patton have raised the question of the antidromic effects of electrical stimulation of any axonal fiber system. These effects are of importance not only because of the resultant blocking action of the impulses on distant synaptic networks but also because of the action of axon collaterals which synapse on adjacent systems of neurons . . ."

Professor Jasper alludes to the reality that intermittent stimulation can maintain a subject under control in this sentence . . . (which again brings us back to the doorstep of a familiar laboratory). He

writes, "Delgado's miniaturized stimulator which the animal carries about with him to be stimulated periodically during 'social' activity (he quotes) is ingenious and useful for certain types of experiments. . . ." He continues a few sentences later to point out, "With the improvements in miniaturization brought about by space and missile programs, we can expect striking new developments carrying over into brain research."

This was his thought in 1961, four years before the public had even heard of Delgado's experiments.

Just as the introduction of gas in World War I was a startling and sophisticated form of weaponry—we must be ready to accept that its equivalent today will go far beyond what we consider "normal". There can be no doubt that controlled distortion of our perception in different ways is the target of the men who are preparing tomorrow's weapons.

E.D.O.M., far from being something out of the far, far future, is closely related to the actual announced work admitted inside scientific circles. Professor Richard L. Gregory, Head of the Perception Laboratory in the Department of Psychology at Cambridge University, has concluded in a recently published paper that "perception is merely a matter of the brain *suggesting* and *testing* various hypotheses about the information presented to it. . . . A person's perception can be misleading if the visual cues are contradictory or if what is being observed

is either *very strange* in itself or seen under totally alien circumstances . . ."

Dr. Wayne G. Brandstadt points out that the underlying mechanism of our biological clock or *time sense* lies in the ribonucleic acid found in body cells. By studying a single nerve cell kept alive outside the body, we see that its electronic potential varies in a definite pattern as each day passes.

A rather peculiar and highly significant indication that the United States is aware that "playing" with time is more than just idle theorizing came recently in North Conway, New Hampshire. "Project Time Out" was conducted with the entire population of the town "cooperating" in one of the widest-scale psychological experiments ever conducted in connection with "time-sense".

Wall clocks were stopped, wristwatches checked at a municipal building, the radio station juggled its program schedule and no time signals were given. Time stopped dead for about forty-five hours for every single living soul in North Conway. This experiment was conducted in May of 1965 . . . and part of its stated "time" objective was to "weigh, as is measurable . . . reactions to its total elimination" . . .

Additional measures to blackout time included:
—All public clocks were masked
—The school ran without time signals for classes
—The noon whistle was stopped

Briefing and de-briefing sessions were held with thirty "controlled families" who had committed themselves to a full blackout. . . . The addresses of these families were known to those conducting the project and they were called upon to see "what was happening."

And so in the sleepy little village nestled in the White Mountains, we crudely "played" with time. What happened? We found out that 40% felt "lost"; 14% didn't; 28% felt more relaxed; and other reactions accounted for 13%. These were the "general" reactions—which could have been predicted by a first term psychology major—but what did the project really set out to ascertain? We are not told what the psychological reverberations were with the 1,104 who were submitted to the novel experimentation.

A few reactions trickled out: "By mid-afternoon I was not only hungry but a nervous wreck, at which point I resorted to tranquilizers" was the admission of an advertising man. A beautician said she felt "uneasy". A secretary noted a "nervous, almost frightened feeling". One person admitted to a psychiatrist that he felt he was floating in mid-ocean without a compass.

* * *

More than a simple test of time sense, Project Time-Out seems to demonstrate our admission here

51

in the United States of the coming era of scientific manipulation of "time".

Make no mistake, the Delgado's, Artemous', Deutsch's, Vasiliev's and the others we have noted, are not dealing in the shadow-world of experimentation. Their discoveries, their research are pure science in the best sense of the word.

So, we may assume, is the work of great companies like Honeywell, Inc., who admitted to this author that they are working on a method to penetrate inside a man's mind and control his brain waves over long distance. This work is under the direction of Dr. Dwayne Selson in Denver, Colorado.

But what of the others—those whose motives are far different? How far has their research gone? To what sinister uses have they already put their tools?

According to The Rumor, there is already in use a small E.D.O.M. generator-transmitter which can be concealed on the body of the person. Contact with this person—a casual handshake or even just a touch—transmits a tiny electronic charge plus an ultra-sonic signal tone which for a short while will disturb the time orientation of the persons affected. Not so precise or predictable a tool as R.H.I.C., it can nevertheless be a potent weapon for hopelessly confusing evidence in the investigation of a crime, as we shall see.

On the brighter side, there are both poetic and

humanitarian overtones to Professor Delgado's statements, which indicate that Behavior Control in the hands of men such as he give us great hope for the future. In a report entitled, "Personality, Education and Electrical Stimulation of the Brain," he says . . .

"Science has *very recently* developed new and powerful tools for the investigation of the conscious brain, and these tools are waiting for the many brains of new students who will use them to full advantage.

"We are in a precarious race between the acquisition of many megatons of destructive power and the development of intelligent human beings who will make intelligent use of the formidable forces at our disposal. The brain scientists may help the educators but they need the educators' help . . .

"These investigations may clarify the basis of human behavior and will probably bring more happiness to human beings than the advances in the physical sciences. Indeed, knowledge of the human mind may be decisive for our pursuit of happiness and for the very existence of mankind."

It is the candor of such men as Delgado, Vasiliev, Artemov, and more recently of David K. Krech, Professor of Psychology at the University of California, which give us some glimmer of light in a dangerous darkness.

Professor Krech's remarks recently to a scientific

53

group show that responsible men realize that shocking and frightening disclosures are coming . . . and the general public must be prepared for them.

In a valuable and frank front page story, *The New York Times* headlined the story of his speech: MIND CONTROL COMING, SCIENTIST WARNS. Dr. Krech was quoted as saying: "I don't believe that I am being melodramatic in suggesting that what our research may discover may carry with it even more serious implications than the *awful*, in both senses of the word, achievements of the atomic physicists. Let us not find ourselves in the position of being caught foolishly surprised, naively perplexed and touchingly full of publicly displayed guilt . . ."

7.

Lee Harvey Oswald

Let us now re-state the R.H.I.C. theory as it relates
to The Rumor. Exactly how could persons like Lee
Harvey Oswald be "controlled" to perform the act
of murder? By Radio-Hypnotic Intracerebral Con-
trol! We have seen that radio transmission can
definitely produce meaningful stimulation of the
brain. For R.H.I.C., the response need not be even
as complex as those we have read about. All that
is necessary is a simple neuromuscular twitch acti-
vated by radio.

One of the few glimpses we have been given by
the scientific community—of the ultra-miniaturized

55

radio-muscle-stimulators—was announced quietly
by Dr. Wen Hsiung Ko of the Case Institute of Tech-
nology in Cleveland. He admitted that receivers the
size of shirt-buttons were in the "experimental"
stage . . . receivers that could be buried in muscles
and used to stimulate them internally.

Dr. Ko's admission to the technical press comes
years after the R.H.I.C. technicians had placed such
implants in operation for less worthy motives than
his. Dr. Ko's experiments are related to the work
that has been done in Europe for many years to
stimulate artificial limbs. His announcement of the
extent to which the equipment has been miniaturized
is no surprise to the researcher of information on
R.H.I.C. implantations.

Now, accepting the feasibility of this, the "radio"
part of R.H.I.C., let us move on to the "hypno" as-
pect. If the subject is placed under hypnosis and
mentally programmed to maintain a determination
eventually to perform one specific act (perhaps, for
example, to shoot someone), it is suggested that
thereafter, each time a particular muscle *twitches*
in a certain manner (which is then demonstrated by
using the transmitter) . . . he will *increase this de-
termination* even more strongly. As the hypnotic
spell is *renewed* again and again, he makes it his
life's purpose to *carry out this act*, until it is finally
achieved.

Thus are the two complementary aspects of R.H.

I.C. joined to reinforce each other and perpetuate the control until such time as the controlled behavior is called for. This is done by a *second* session with the hypnotist giving *final* instructions. These might be reinforced with radio-stimulation in more frequent cycles. They could even carry over the moments after the act to reassure calm behavior during the "escape" period (as in the case of Oswald) or to assure that one conspirator would not indicate he was aware of the *co-conspirator's* role or that he was even *acquainted with him*. This might serve to block so much as a *mention* of the other's name.

(From the testimony before the Warren Commission by Jack Ruby.)

> RUBY: "Very rarely do I use the name Oswald. I don't know why. I don't know how to explain it"

(From "Dallas Justice" by Melvin Belli—Page 102.)

"He (Ruby) rarely called Oswald by name."

Consider how very difficult it is for anyone to discuss the assassination without using Oswald's name! R.H.I.C. is a very simple albeit fiendish combination of *two* known scientific tools joined in a sophisticated modification to produce a theoretically predictable result. R.H.I.C. is one procedure that *can* explain the events in Dallas.

57

The questions in rebuttal to this stand come quickly to mind.

"Can anyone . . . using R.H.I.C. or not . . . be hypnotized to commit a criminal act so brutal as murder? Isn't it true that one will not perform any act under hypnosis that one wouldn't in a perfectly uncontrolled state?"

The answer is simply no.

Dr. Theodore Barber of Harvard University in *The Journal of Psychology* states that a good subject will commit anti-social or dangerous acts if first convinced by the hypnotist that his behavior is normal and proper: such acts (as one account of Dr. Barber's work puts it) as *throwing acid at the experimenter!* "Two recent extensive reviews of this problem have not failed to note that since the good subject accepts the hypnotist's words as true statements, an unscrupulous hypnotist can induce the subject to commit 'anti-social' acts."

Again the skeptic's retort may be "All very well to theorize . . . but has it ever been proven that a person under hypnosis will actually *do* these things?"

The answer is an unqualified yes.

Under the hypnotic spell of Bjorn Schouw-Nielsen . . . 28-year-old Palle Hardrup walked alone into a bank in a suburb of Copenhagen in March of 1951. In the course of a hold-up that Schouw-Nielsen had "controlled" him to carry out, he calmly shot two

bank employees to death. When he was caught, Hardrup confessed he had done the killings under hypnosis. Tried in 1954, Hardrup was found guilty of manslaughter (because he was hypnotized "in a state of mental abnormality") and was committed to a prison mental institution. Schouw-Nielsen was also convicted of manslaughter ". . . through having planned and by various means, including hypnosis, instigated Hardrup of the crimes." He was given a life term.

The fact that hypnosis was *the* tool of control was established by Dr. Paul J. Reiter, one of Denmark's leading psychiatrists and an expert in hypnosis.

Perhaps the loyal opposition now adds . . . "Very well, admitting the fact that hypnosis *will do* what is claimed . . . has a proven case of the combination of radio *and* hypnosis ever been explored?"

The answer is a probable yes. Although the very basis for using R.H.I.C. is to control behavior without detection . . . there is *one case* that comes immediately to mind as a likely example of R.H.I.C. being used on a victim.

We refer to the 1950 defection of Dr. Otto John of the top echelon of West Germany's security and anti-espionage efforts. He defected to the other side allegedly because of the hypnotic brain-washing performed on him by a Soviet Agent.

This occurred shortly after he told friends he was going to Charite Hospital in Berlin. It was there,

according to the rumors, he underwent an operation for a "brain implant." Vague as this information about the operation is, there is a strong indication that this was one of the first uses of R.H.I.C.

The Otto John case is still shrouded in mystery and the files are inaccessible, being locked up and guarded by the German Federal Police.

In his excellent report on the incident, Joseph E. Brown related a few years ago, "Some para-psychologists insist today that the agent . . . perhaps well trained in hypnotic suggestion, implanted the idea of defection in John's mind during their frequent visits together *without John even knowing it.*"

8.

The Plan To Go To Switzerland

Returning to our investigation of The Rumor, we note that in the period from 1958 to 1959, a figure in the case decided to go to Switzerland and apparently to Germany. In Switzerland, he would, he stated, like to attend the Albert Schweitzer College in order to, among other things, "broaden my knowledge of German and live in a healthy atmosphere and Good Moral atmosphere."

The man (under an influence? . . . perhaps one that continued long after) who applied for a passport to Switzerland and Germany on September 21, 1959, was Lee Harvey Oswald. The world has a

picture of Oswald as a Castro-Moscow sympathizer. That would lead us to accept his interest in Spanish and Russian . . . But little known to us was his interest, by his own statement, in German!

The "strong" man that those close to Lee Oswald said was his *best friend* in those months before the assassination was George De Mohrenschildt. This clever, sophisticated man, whose international background included friendships with Jackie Kennedy's father and mother, somehow found time to attune himself to the conversational sparkle of the Oswald household.

George De Mohrenschildt was born in Mozyr, Russia. His father was of German descent. George, unlike his brother, obscured his German heritage by a change of name from *Von* Mohrenschildt to *De* Mohrenschildt. This fact was brought out by assistant counsel Albert Jenner in information gathered for the Warren Report. Jenner has since been condemned along with the rest of the Commission for lack of zeal in digging out the real facts. Nevertheless, it is interesting to note that he scratched far enough below the surface to uncover the fact that in the 1940's De Mohrenschildt was involved in a business venture called Facts, Inc., with a questionable partner, a "distant" cousin named Baron Maydell. Jenner suggested that Maydell was accused of being a German spy. De Mohrenschildt admitted that people considered Maydell pro-Nazi.

62

The Plan To Go To Switzerland

A particularly odd coincidence showing up as a result of Jenner's interrogation has to do with De Mohrenschildt's father. He was seized by the Communist regime for being outspoken, but decided later not to flee from Russia. To quote De Mohrenschildt, his father "heard from somebody that they (the Communists) had become liberal" and so he "stayed in Minsk . . ." Lee Harvey Oswald was later to stay in Minsk.

One brief quote from the exchange before the Warren Commission between Assistant Counsel Albert Jenner and De Mohrenschildt.

In connection with questioning about photographs that De Mohrenschildt did or did not take of the Aransas Pass U. S. Coast Guard Station (presumably during World War II):

> Q. You went to Aransas Pass, and what did you do there?
> A. What do they say we did?
> Q. Did you take some photographs?
> A. Possibly of each other.
> Q. You took no photographs of the Coast Guard Station there?
> A. I don't recall that.
> Q. Did you make any sketches?
> A. Yes, because I like to sketch. I sketched the dunes, the coastline but not the Coast Guard Station. Who gives a damn about the

Coast Guard Station in Aransas Pass?

Q. I can tell you that is what got you into trouble.

A. Is that so? Well, you are the first one to tell me about that. On the way back to the Pass, some characters stopped the car and came out of the bushes and they said, *"You are a German spy."*

Later in the testimony, De Mohrenschildt admitted to knowing a little more about the "characters."

"I have the impression they told me they were from the FBI and they followed me all the way from New York."

In the bright spotlight trained on the events in Dallas, the principals speak Spanish or Russian . . . the scenery is backdrops of Cuba, Moscow and Minsk.

In the shadows, the language and influence is German. In this one discrepancy lies the key to an understanding of the ways in which Lee Harvey Oswald may have been controlled!

Who planned to use a tool like R.H.I.C. to control his actions? Why was he chosen?

In the bars and cafes of the world where tired intelligence men of all nations take their coffee or wine, the inside talk of the profession often turns to Oswald. He is a natural subject for the after hours trade-talk that they love so dearly. Oh, it's discreet

enough. Men who work in the same department, in the same office, even in teams on the same assignments pass the time this way. Trading tidbits on Oswald, theories about his possible connections with the various intelligence branches, foreign and domestic, is a popular pastime.

The initial basis for shop-talk speculation as to Oswald's connections "higher up" rests simply upon his access to money. Money to travel with.

Ask your next door neighbor if he'd like to travel more . . . he'll probably look at you oddly and reply, "Of course, if I had the money!"

Lee Harvey Oswald always had the *time* (which means loss of regular salary) . . . and he always seemed to have the *money*.

He travelled to Los Angeles, to Mexico, to London, to Moscow and back. He travelled to whatever spot his strange destiny drove him . . . and when he wanted to!

In a questioning session with Wesley J. Liebeler (Assistant Counsel to the Warren Commission), Nelson Delgado, a "buddy" of Oswald's during his Marine days, said in part, ". . . and just after he started receiving these letters—you—see—he would never go out, he'd stay near the post all the time. He always had money."

Liebeler noted the point and made Delgado repeat the answer.

Oswald had money to pay for the tuition to a

college he was interested in. He had the money to pay back the State Department for the loan they made to him for his return from Russia. He had the money to buy firearms, travel constantly, and money for "causes."

An example of this occurred when he printed literature on behalf of the Fair Play for Cuba Committee without their knowledge or authorization and at his own expense.

A New York City radio personality, Long John Nebel, has stated that a Lee Oswald phoned him from Louisiana and offered to make the trip to New York *at his own expense* just in order to discuss political matters on Nebel's top-rated discussion show. (Nebel shrewdly assayed Oswald's personality and declined the offer.)

For certain things . . . Lee Oswald . . . had *money* . . . make no mistake about it. Not for Marina or his home particularly . . . but for expediting his *actions*.

Did this money come from the CIA, FBI, State Department, Castro or the Soviets? No, not according to The Rumor.

But it was there to be had . . . made available to him by some group . . . for a reason.

The simple fact is the most convincing argument to men who follow the professional intelligence craft . . . that he was "somebody's man."

The Rumor crystallizes a picture of Lee Oswald as a "high-jacked sleeper." In intelligence jargon

that simply means that he was selected by one group and maneuvered into the orbit of *another* group which trained and prepared him for work in the future when they (the second group) might have need for his "special" qualifications. The first group had secretly spotted him as an ideal person to use *as a tool* in a very special operation. His desirability was even higher because the blame for his actions (should he be caught) would fall quite naturally on the second group. He was the man high-jacked by some of the most amazing and sophisticated methods known to modern science and secretly—without his own conscious knowledge—used as a key man in the plot to kill John F. Kennedy and "rig" the Stock Exchange. He was to play a major role in the crime of our century!

Why *this* man? If the planning of dark deeds was so ambitious, why select the rather unimposing Lee Oswald? The answer is not simply that he was deeper, brighter, and "cooler" than most people gave him credit for being. This was all true, but it was *not* the reason.

The reason is that pure chance put him in the position where he could be "prepared" for his usefulness. Here, then, is The Rumor at its stunning high point . . . of intricacy.

This is how Oswald was "conditioned" for the final act. Shortly after his 17th birthday, Lee Oswald enlisted in the U. S. Marines. His interest in

Marxism became known to all those in his barracks and eventually this word was carried, either deliberately or by accident of idle gossip, to the civilian world in Los Angeles.

An inquiry was begun by The Group behind The Rumor and "he" was catalogued and filed. Unbeknown to Oswald, he was to remain under observation and closer and closer control from that time on and for the rest of his life.

Stage one of that control was to penetrate his political and philosophical beliefs . . . to dissect his thinking processes in such a way that an evaluation could be made as to the extent he *could be controlled.* This was probably begun in June of 1959. As part of this procedure, he was tested for susceptibility to hypnosis under casual party conditions. He responded quickly and this was duly noted.

On leave from the Marines for week-ends, Oswald was influenced deeply by Mr. One, the center figure of The Group, and he was prepared for a destiny that lay four years ahead of him. His role— the role *they* had selected for him—was to kill the then-to-be-elected President of the United States. The identity of that President, as amazing as it seems, was not of course even known to the members of The Group. Only by chance of the ballot was John F. Kennedy to be Oswald's target . . . A slight turn in the election totals and Richard Nixon would have been the victim!

The Plan To Go To Switzerland

Of the man who made the first contact and initiated Oswald into a maze he was never to find his way out of, we can surmise a few things.

He was probably German or of German-Russian descent, well educated, a philosophy major with previous wartime experience probably in the Military Intelligence. He had very probably some training in the neurological and psychological fields and worked voluntarily with or was captured by the Russians during World War II. It is likely he spent time in Moscow, Leningrad and Minsk. He knew Europe well and was at home in South America. For purposes of simple identification, we refer to him as Mr. One.

Mr. One's task (for reasons which will later be obvious) was to convince Oswald to quit the Marines and leave the country.

The argument was not, as you might assume, that Lee should go to Russia directly to live. Far from it. Although Mr. One knew full well that Oswald had Marxist tendencies and a great curiosity about Russia, Mr. One's tactic was to interest Oswald in "finding" himself through further study of philosophy. Oswald should, implied Mr. One, study in an atmosphere of the clean, moral, good life. Such a place was Germany. Besides Germany, however, there was Switzerland where he could acquire a basic background in philosophy which he lacked because of an "inadequate" American school

system. This would enable him to "catch-up" so that he could study in Germany on an equal level with the other students.

How was the relatively poor Lee Oswald to finance this expedition into higher education and soul finding? The fatherly protection of his new-found friend was extended. If he had the determination to "make something" of his life, by following Mr. One's advice . . . the least Mr. One could do was advance a modest amount for travel expenses. Not much, mind you—Mr. One made no pretense of flashing big money—just *enough* to sway a confused young Marine's mind.

How does The Rumor check out on these pertinent points?

They check out all too well for our peace of mind.

A completely different Lee Oswald begins to emerge as we do that checking.

Point One. Something or some one (Mr. One?) caused Oswald to return after a brief leave from his Marine Base in California and tell his close Marine friend Nelson Delgado that "he was going to a school, and this school in Switzerland was supposed to teach him in two years (in 6 months) [Sic] what it had taken him to learn in philosophy over here in two years."

At another point in his testimony, Delgado adds, "I can't for the life of me recall where I got the scoop that I thought he was going to some school

in Berlin, and I was thinking of going over there
to see if I could find him . . ."

What rapport would Oswald, the Cuban-Russian
sympathizer, have with the German way of life?
The *language* astonishingly enough caught his
attention.

In his testimony, Nelson Delgado offers these
startling thoughts for us to ponder on . . . Delgado:
"Well, like I say, he tried to teach me Russian, but
then another time, I had some thought that what
he was speaking to me was German." And then
later in the same testimony . . . Liebeler: "It seemed
to you like it was German?" Delgado: "Like Ger-
man, yes." Still later, "I could only assume it was
Jewish or German and later on when I was in Ger-
many, I think . . . I am pretty sure . . . it was Ger-
man that he was speaking". At another point in the
questioning, Delgado (by his own testimony, Os-
wald's closest friend in the Marine Corps) was asked
if he had met Oswald at any time when he (Del-
gado) was in Germany. Delgado: "No, I wanted
to . . . I knew that he was over there and going to
school . . ."

From a report to the Warren Commission:
"In April 1960, Mrs. Oswald advised that subject
(Oswald) had informed her by letter sometime dur-
ing spring or summer of 1959 that he had made
arrangements to attend the Albert Schweitzer Col-

lege in Switzerland. She also advised that a few days previous to April 28, 1960, she had received a letter from his college to the effect that subject was expected on April 20, 1960."

In Oswald's letter explaining why he wanted to attend the Albert Schweitzer College in Switzerland, he wrote:

> In order to acquire a fuller understanding of that subject which interests me most, philosophy. To meet with Europeans who can broaden my scope of understanding. To receive formal education by instructors of high standing and character. To broaden my knowledge of German and to live in a healthy climate and Good Moral atmosphere.

In June of 1959 he sent the college a $25.00 registration fee and a letter saying he was looking forward to a "fine stay."

The $25.00 deposit must not be disregarded in evaluating whether or not this application was a blind to cover a trip actually intended for the purpose of defection. As a dodge, the deposit was not necessary. It was needed only if Oswald felt he was definitely going to the college. If it was intended as a "red herring", it was to fool Oswald himself. Perhaps it was placed in his hand by Mr. One . . . who knew full well that young Lee Harvey was not to

find himself changing his mind about that college until he was so persuaded upon reaching Europe.

After securing release from the Marine Corps, it is a matter of record that in September 1959, Oswald applied for a passport at Santa Ana, California, stating that he planned to leave for Europe on the 21st of September to attend the Albert Schweitzer College and, among other stops, to visit Germany.

His passport was granted shortly after. He sailed on a freighter from New Orleans on the 20th of September. We can assume that Mr. One had requested Oswald to make a stop in London to meet him and together they would go about shaping the destiny of this budding psychology and philosophy student . . . whom he was sponsoring financially. At any rate, to London went Lee Oswald. His meeting there resulted in the first truly important bit of control exerted over his destiny.

Lee arrived in Le Havre on October 8th and then proceeded to his London rendezvous. Upon arriving he met with Mr. One. This was the point at which Operation Control went into full action.

Mr. One informed Oswald cheerfully that quite by accident he had met an old friend in London, who was one of the top psychology brains of Soviet Russia. There was exciting experimental work going on and his friend's work called for experiments with at least one person with a completely American psychological point of view. Preferably this person

should have lived *recently* in the U.S. and have his typical American attitudes and U.S. conditioned-responses intact.

Oswald's eyes widened at this point. Did this mean that Soviet Russia was going to invite him to come and be the guinea pig for the advancement of Russian science?

Not quite, he was gently told. The Russian professor did not have that power, and indeed even if he did, would prefer not to claim so close acquainceship with any American that he would even suggest his name. However, if Oswald were to visit Russia for a long period of time . . . The Professor could "accidentally" hear about this friendly Soviet-oriented American and *request* then that he be offered or assigned a post in his experimental laboratory.

Then, of course, The Professor would use his *local* influence to see that Oswald enjoyed a higher standard of living in Russia than an American would ordinarily. Later there would be a decoration by the Soviet Government!

Oswald took all this in. Could he simply apply for a tourist's visa and then go about waiting for his call to scientific glory? It intrigued him, no end. . . . He was ready!

Mr. One pointed out that therein lay the drawback. The experiments would take a longer time to

carry out than a tourist's visa would afford him. Oh well, sighed Mr. One. It was just an idea. Fascinating, but not practical. Oswald said nothing. He went home to his London hotel room and thought out the situation.

The next morning, as Mr. One knew he would, Oswald reopened the subject. Supposing . . . he defected . . . Oswald offered . . . and volunteered to stay permanently in Russia?

If Oswald were able to reach this acceptance by the Soviet government, Mr. One agreed, The Professor would, of course, then call for his services and he would indeed be important in the Russian scientific Scheme of Things. It might lead to Very High Honors indeed.

Lee Harvey Oswald, in Minsk, 1961, with his KGB
undercover officer "friends."

9.

Oswald Works Toward A Goal

In the next four days, Oswald worked frantically at his new-found goal . . . to get a Soviet visa. He flew to Helsinki where the visa was granted and he entered Russia on the 15th of the month.

He was in his glory. Mr. One had assured him that if he could convince the authorities that he was a sincere defector, and wanted Russian citizenship . . . high adventure lay ahead of him.

Mr. One's analysis of Oswald was accurate. He was intrigue-prone and constantly yearning to play a role of some importance that the world would have to applaud, or at least take notice of.

Oswald's impatience to impress the Soviets and become accepted was at fever pitch. At one point, when he thought his plan would fail, he made a crude attempt at suicide.

He waited patiently in his hotel room for a knock on the door from Rima Shirokova, who was assigned to keep an eye on him by the Tourist Office. When she did, he made a small scratch in the skin on his wrist—knowing full well that the door was unlocked and she would come in and "save" him.

After an initial chilly reaction to his plea to be allowed to stay, he decided on a more tricky approach. Quite aware of the fact that Intourist was examining his possessions when he was out of his hotel room, he left a deliberately prepared mock "diary". This contained naive tongue-in-cheek references to his sincerity concerning his desire to become a Soviet citizen. Oswald thought that finding and reading these—his supposedly "secret" thoughts—would convince the Government that he was not up to any game that they need to be suspicious of.

The amusing thing about this diary is that many who have written about Oswald's Russian days have taken it as a serious "straight" document. They have, as a result, reprinted as his actual thought such ridiculous entries as . . .

"I am shocked!! My dreams! . . . I have waited 2 years to be accepted [Author's note: Not so].

78

Oswald Works Toward A Goal

My fondest dreams are shattered because of a petty official. . . . I decide to end it. Soak wrist in cold water to numb the pain, then slash my left wrist then plaug [his spelling] wrist into bathtub of hot water. . . . Somewhere a violin plays, as I watch my life whirl away. I think to myself 'How easy to Die' and 'A Sweet Death, to violins!' "

There! . . . thought Oswald. . . that ought to convince them that I am just a simple, dedicated man who will not be stopped. Maybe he was right. He convinced a few people back home in the bargain.

After the suicide attempt was "thwarted" by Rima . . . Oswald added this to the diary: "Poor Rima stays by my side . . . I tell her go home but she stays . . . she is 'my friend'."

Some whimsical streak of irony in Oswald's nature led him to put quotation marks around the more obvious syrupy terms like "my friend" and "A Sweet Death". He was, with all that was to be accomplished . . . cool enough to momentarily "put them on". . . .

A little shaken by the fact his "suicide attempt" found him transported off in efficient style to the local psychiatric ward, Oswald decided to condition his attitudes to please the doctors and get out as soon as possible.

Guessing that they would be more at ease about his case if he convinced them that he was going to give up his efforts and go back to the States . . . he worked toward this end. They were convinced and he was released.

With the feeling of power that his projected rendezvous with The Professor gave him, he renewed his efforts to become a Russian citizen.

Then came a studied dramatic visit to the American Embassy where he dropped his passport on the receptionist's desk and waved a note which made his renouncement of his ties to his home country "official". He then manufactured more grist for the strange action he had made of his "diary". He wrote (with a none-too-subtle hint to whoever pried into its pages) "I leave Embassy, elated at this showdown, returning to my hotel I feel now my energies are not spent in vain. I'm sure Russians will accept me after this sign of my faith in them."

Then, after writing a few violently anti-American letters home (deliberately worded to further convince those who inspected his mail) . . . Oswald sat back and waited.

On January 4, 1960, he was summoned to the Passport Office and told he could stay indefinitely.

Instantly, he relayed this news by a pre-arranged code message to London. Mr. One contacted The Professor and Lee Harvey Oswald was placed upon the threshold of an incredible experience.

$500.00 was rushed to him and he was instructed to head immediately for Minsk.

There, where The Professor was waiting for him, Mr. One's promises were kept. A few other "extras" were to change Lee Oswald's destiny, however, in a tragic way.

In Minsk, Lee Oswald was contacted and welcomed by The Professor, who reassured him that he would indeed be part of a super-secret Russian scientific program in the study of behaviorism. It was a highly sophisticated off-shoot of the work initiated years previously by Vasiliev in Leningrad.

The Professor did not go into great detail as to exactly what role Oswald was to play in the experiments, but his cheerful manner set Lee at delighted ease.

He was assigned an attractive flat with a terrace view of the Svisloch River. His rent would be $6.00 a month and his allowances would be $160.00 a month, a most handsome sum in Minsk.

Oswald relaxed and, in conversation with The Professor, confided how he had used his "diary" to convince Moscow to let him stay in the country. The Professor looked disturbed. Was he keeping the diary up? No, said Oswald, his purpose had been accomplished. The Professor quickly warned him that he must keep it up as long as he was in Russia so as not to disturb the pattern of his behavior. He should not, advised The Professor, always write the

81

most complimentary things. It wouldn't look very convincing, because all Russians had things they secretly fretted over. Just don't make the complaints too severe. Oswald, startled to find The Professor was not all-powerful in Minsk, agreed. He was later to find this insecurity, of course, on many levels.

Oswald was then told by The Professor that the work he would assist in, was experimental research in the field of electrical stimulation of the brain at No. 5 Krasnaya Street, in the Experimental Section of the Electrotechnical and Instrument Building. Exhibit No. 985 of the Warren Report confirms this indeed was where he worked.

During the next twelve months, Oswald performed his work and tried to adjust himself to Russian life. His work with The Professor was not too interesting, but he was assured something "important" lay ahead for him. Indeed, it did.

Just how long Oswald would have waited for that something important, we are never to know. Romance intervened and speeded up The Professor's plans for Oswald.

Badly shaken emotionally by an infatuation with a girl named Ella German (who refused to marry him), Oswald suddenly showed signs of going to pieces.

Quick action was decided upon . . . for Lee was

more important to their future plans than he was allowed to suspect.

Marina Nikolaevna Prussakova, a clever attractive beauty, suddenly appeared in Lee's path at a dance.

Events followed in quick succession. Much to his own amazement, Oswald felt himself swept up in a romantic maelstrom which was designed to restore his confidence and take his mind off Ella. It worked.

In his diary, which he was now half-heartedly keeping up as per The Professor's stern instructions . . . he wrote, ". . . the transition of changing full love from Ella to Marina was very painful . . . especially, as I saw Ella almost every day at the factory, but as the days and weeks went by, I adjusted more and more."

The Professor, satisfied that he would be charmed by Marina, informed the slightly dazed Oswald that he was now about to participate in his "big contribution" to the project.

Let us clarify for a moment, Mr. One's motives . . . and his exact plan for Lee Oswald.

Mr. One's idea was to direct Oswald into a situation where he would be used by the Behavior Control Project in Minsk and be prepared as a "sleeper" to return to the United States for use at some future time. How would he be used? In almost any manner that Soviet Intelligence decided.

Were We Controlled?

Lee Oswald was to be utilized as . . . (and now you must clear your brain and put aside your preconceived notions of what espionage and sabotage are *today*) . . . a R.H.I.C. controlled person . . . somewhat like a mechanical toy. A R.H.I.C. controlled person can be processed (as Oswald was in Minsk), allowed to travel to any country . . . and be put to use even years later by the application of R.H.I.C. controls. In short, like the toy, he can in a sense be "wound up" and made to perform acts without any possibility of the controller being detected. Under R.H.I.C., a "sleeper" can be used years later with no realization that he (the "sleeper") is even being controlled! He can be made to perform acts that he will have no memory of ever having carried out. In a manipulated kind of kamikaze operation, where the life of the "sleeper" is dispensable, R.H.I.C. processing makes him particularly valuable because if he is detected and caught before he performs the act specified . . . *nothing* he says will implicate the group or government which processed and controlled him.

For example, if it were deemed necessary for an assassination attempt to be made on a head of state . . . a R.H.I.C. controlled person might attempt and fail and be caught. He *could not* implicate whoever controlled him to do the deed . . . because he would either not remember having done it . . . or honestly believe that it was his own idea! A more efficient

84

kind of human intelligence tool has never been devised!

How much information does the C.I.A. have about this sort of behavior control? We have no way of knowing for the C.I.A. tells only what it chooses to tell.

Nevertheless, in weighing The Rumor, we find it interesting to note the following item from "A Primer of Assassination Theories," published in *Esquire* magazine.

"Since Oswald spent considerable time in a Soviet hospital, a few Commission lawyers entertained the theory that Oswald might have been brainwashed and conditioned to be a 'sleeper' assassin; then he went haywire (i.e. he was accidentally turned on). The Commission decided to send a letter to the C.I.A. requesting information on the 'present status of Soviet mind-conditioning techniques.' A few weeks later, a C.I.A. agent replied that this possibility was still 'a main school of thought' at the C.I.A. on the assassination, and although such techniques were still in a relatively primitive stage, this form of conditioning could be induced by drugs. The theory, however, was not further developed."

*　　*　　*

Were We Controlled?

Don't think that R.H.I.C. belongs in the never-never land of fantasy. Let us rip aside the veil of secrecy for just a moment from two other sophisticated tools in current use by world-wide intelligence operators. They are not nice tools. The intelligence field today is not one for the squeamish.

Number one . . . is called by some in the craft the "needle". It is just that. A sharp needle similar to a hypo but easier to conceal. If the target person is walking down a crowded street or corridor, an intelligence agent simply walks by him, brushing against him, touching his leg with the needle and in a few seconds the target dies of a "heart attack". There is no reason to suspect the cause of the death is anything else . . . and so it is reported to the press. Number two: Most of the so-called investigations about wire-tapping are concerned with apparatus that is long since out of date. The newest tool is a powder which is sprinkled surreptitiously on a man's suit or overcoat while he is walking in a crowd or standing in an elevator. Until the suit is cleaned, the powder acts as a kind of transmitter for the use of radio pick-up nearby. His clothing transmits his voice and the conversation of those near him a sufficient distance for those eavesdropping to check him out.

At least one very prominent American labor leader has complained privately that he *knew* this method was used on him.

86

Like R.H.I.C., the powder-pick-up is an offshoot of a legitimate medical discovery, which enables doctors to study various functions of the human body by radio.

We have noted these two devices which have been in use for the last five years in order to give some idea of the sophistication of the newer "tools".

In Minsk, the plan was to have Oswald processed for control by R.H.I.C. . . . and then released by the Russians to return home and perhaps join a handful of other "sleepers" similarly "prepared".

The purpose behind Mr. One's manipulating Oswald toward this end was not to do the Russians any favor! Mr. One couldn't have cared less (nor could his conspirators) whether Oswald ever proved useful in the future for the Soviets. Mr. One understood R.H.I.C. and he knew how to manipulate. This he had learned in Russia working with The Professor years before. He did not have the skill to perform the ultra-sophisticated cerebral operation necessary for R.H.I.C. processing. That *had to be done in Minsk* in the hospital . . . by The Professor. It was.

Shortly after he met Marina, Lee Oswald was informed that he was going to become more valuable to the "research project", and that he would soon become a central figure in the project. How was his health? This was important. He must not delay things once the full experiment was under way.

87

Oswald replied honestly enough he had experienced some difficulty with his hearing, both as a child and as an adult.

After an examination, an associate of The Professor told Oswald that he indeed did have a condition that could crop up and be distressing and time-wasting. There would be a minor operation performed free, and certain polyps in his nose would be removed which they felt would assure him of better health. (In truth, his adenoids would be removed.)

A little apprehensive, a little flattered, Oswald agreed meekly.

There was one other thing, The Professor's assistant added. While on the operating table and under the anaesthesia . . . there would be made a very simple exploratory incision at the back of his head for making certain harmless tests. This would be invaluable in carrying out the muscular manipulation-by-radio experiment that was to climax the work Oswald was to do in Minsk.

The only inconvenience would be a brief stay in the hospital and the assistant promised that the tiny incision would be of the very latest type that would be almost invisible. His hair would hide it in a few weeks.

Oswald suspected that some of the concern about his hearing was directly linked to their desire for the chance to make the tests. He knew that the electronic equipment the experimental laboratory was refining had to do with this kind of experi-

mentation. Their request sounded logical. Primarily, Oswald was pleased. His ears had always been a sore subject with him, and he secretly feared increasing hearing disability.

He asked a few questions of The Professor and his associate as to exactly how the operation on the nose would affect his hearing. Satisfied with the answers, he consented.

The Professor beamed and hinted broadly that Oswald would *certainly* then be in possible line for public decoration when the project was completed.

According to official Russian records, Lee Harvey Oswald was admitted to the hospital in Minsk at 10:00 a.m., March 30, 1961. The diagnosis released later as to why he was supposed to be there was put this way: "Admitted with complaints about suppuration from the right ear and weakened in hearing." In all the routine of covering up the real reason for Oswald's stay, there was one slight oversight. He was hospitalized for eleven days for an "adenoid" operation. Eleven days for an adenoid removal is, of course, preposterous. In austere Soviet Russia it was particularly ridiculous!

What really happened on that operating table? Oswald never knew. After he was placed under anaesthesia, advanced technique was employed to implant a miniaturized radio receiver which would produce a muscular reaction in his cerebral region . . . a receiver no larger (as we have seen is possible

89

in the admissions of Dr. Ko) than a man's tiny shirt button.

We will spare you the gory details but ironically we can note that if The Rumor is true, then indeed special photographs were taken of his head. . . . They were Polaroid Roentgenograms to enable the surgeons to draw the desired position of the implant, and after determination of the entrance point, direction and depth, the tiny receiver was inserted.

Not nearly as delicate as the job of implanting actual electrodes inside the skull (the task facing Dr. Delgado's team) this implant would more than suffice for the purposes of the R.H.I.C. controllers because hypnotic suggestion carried such a large measure of the burden of the operational technique.

Only in Minsk has science refined the implantation of receiver and stimulator in such manner that by using ultra miniaturization, it can be accomplished leaving no sign on the surface of the back of the scalp (once the minute incision has healed).

Thus, Lee Harvey Oswald underwent surgery on April 1, 1961 and was discharged on April 11 . . . to remain for the rest of his life—without his knowledge—a completely efficient human tool . . . subject to "control"!

10.

Jack Ruby

Although he was R.H.I.C. programmed not to talk, Lee Oswald's very presence . . . should he be caught alive . . . represented the greatest single danger to The Group.

To insure that there was available to them a murder instrument which could eliminate him, they sought out an assassin's assassin.

Was the late Jack Ruby the perfect choice in Dallas? From almost every angle, he was.

He had a dyed-in-the-wool "tough guy" background. He was familiar with the business of handling a revolver. As a cafe owner, he had followed

91

the prudent course of making and keeping friends in the Police Department. These friendships were numerous and in some cases surprisingly deep. Jack Ruby was a man who could, at least in the center of town, pass through police lines. His familiar face was his "police press card". In short, if anyone could (without attracting undue attention) reach the areas where Lee Oswald would be questioned or held, should he be taken into custody, it was Jack Ruby.

The Group found it easy to contact Ruby. Almost anyone who bought liquor in his clubs could meet him if they went about it carefully enough. The Group was careful!

Jack Ruby was to be R.H.I.C.-controlled to kill Lee Harvey Oswald upon instruction.

Perhaps the only major slip in the entire plot occurred in dealing with Ruby.

We must presume that, at this later period, a greatly simplified procedure for R.H.I.C. processing had been developed which The Group felt they themselves could administer in the United States.

Following this line, we would then assume that on a given occasion, Ruby was placed under hypnosis . . . perhaps at a party or perhaps by some "performer" who was pretending to offer a casual audition for the Carousel Club—but in any case, without Ruby's knowledge.

When under hypnosis he was duly processed by

92

a newer method of scalp injection that would render him subject to radio manipulation. It was, of course, done without the careful charting of the cerebral area that was possible during Oswald's hospital stay.

Was it done incorrectly? Was the lack of skill in handling Ruby later to become obvious? Perhaps it resulted in brain damage.

Compounding the problem was the fact that the hypnotic state Ruby was placed in was not handled correctly and the experience was almost like a disagreeable hallucinatory experience that was to disturb his conscience in the days and years to come.

The most important error however was on the surface, a simple and seemingly innocuous oversight.

After he was placed under the hypnotic spell, and while they were preparing him for application, the people in the room were *talking*. They were talking . . . evidently among themselves while passing time . . . waiting for the completion of the treatment.

Ruby's hypnotic state, while it defied a number of ordinary hypnotists' tests performed on him, was *not* as deep as it should have been. As a result, Ruby somehow grasped and kept in some corner of his memory what they said. This knowledge has been plaguing him ever since. He is aware of the facts, he became aware of them while under treatment, but he does not quite realize *where* he got them.

93

The conversation he overheard was evidently between two members of The Group . . . speculating perhaps on the worldwide possibilities of mass behavior control . . . possibilities that revealed the kind of dreams of dictatorial glory that Adolf Hitler dreamed.

Jack Ruby, as has been often noted, was very aware of the fact that he was Jewish. A complex, and in some ways a very sensitive man, he felt strongly about his religion and the problems of his "people".

What they said (while they thought he was unable to comprehend) may have so disturbed his subconscious that it affected his conscious mind sufficiently for him later to remember this conversation.

This was the Achilles Heel of The Group's operation, as we shall see.

Under hypnosis, Jack Ruby was carefully programmed to set his mind to the task of shooting Lee Harvey Oswald . . . should Oswald ever "do anything to President Kennedy." Over and over this thought was implanted while he was under hypnosis. Every time the radio controls were applied to his brain and there was a slight twitch or contraction in his head, he was to *re-double* his determination to execute Oswald should he ever perform such an act.

This part of the R.H.I.C. plan was thorough and it was set to be triggered by a single statement. The statement might have been as simple as . . . "Now

94

Jack, now you must kill Lee Oswald". Over and over he was taught that he would actually proceed into action when *that statement* was addressed to him. Prior to that, he was simply to concentrate on the thought that he would perform the act . . . should Oswald harm the President. He would do it because of his love for the President and his grief for Mrs. Kennedy's suffering.

It was important that this be a spur-of-the-moment act to all appearances, and therefore it was necessary that Ruby not acknowledge that he knew of Oswald before the assassination.

This point was hammered into Ruby's subconscious. *He did not know Oswald.* He had never met him. He was *not even familiar with his name*—before the killing that might occur.

All of this, Ruby was controlled to do.

Later, the block against admitting he knew Oswald or had planned far in advance to kill him, had a curious (but telling) effect on his behavior that others noticed. Without a knowledge of the R.H.I.C. technique, they could not, however, analyze the significance of such behavior.

In his account of his work with Ruby, Melvin Belli has this to say in *Dallas Justice*: ". . . One topic he (Ruby) backed away from. Never once did he voluntarily mention Lee Oswald by name. . . . Never, as far as I could see, was (Ruby) willing to concede that there had been this living, breathing human

95

being who had died at his hands. It was strange because he had the capacity to summon up sympathy for almost anything."

For evaluating The Rumor, provocative evidence is at hand on all sides to point to the possibility that R.H.I.C. was used on Jack Ruby. At his trial, many distinguished experts' testimony indeed tend to make it seem almost impossible for it to have been anything else. These experts simply were not connecting the symptoms with R.H.I.C. because in all probability they do not even know it exists.

Some of the indications that Ruby gave as to the cause of his actions obviously puzzled some of the specialists who talked with him and examined him.

The conclusions they arrived at are sometimes startling in how they relate to the Rumor. Here is an example: In a seventeen page report on Ruby, Dr. Walter Bromberg, psychiatrist and the clinical director of Pinewood Psychiatric Hospital at Katonah, New York, used these words . . . Jack Ruby was, he said, "pre-set to be a fighter, to attack". Dr. Bromberg never knew how close he was to an amazing possibility. His diagnosis was almost extrasensory in its depth. "Pre-set" indeed was as close as one could get to describing exactly what R.H.I.C. was all about.

In different portions of his report, Dr. Bromberg used phrases that seem more than coincidence in

the way they can be related to a person under R.H.I.C.

His act was in response to an irresistible impulse. . . . "Definitely there is a block to his thinking which is no part of his *original* mental endowment." (Italics ours.)

Dr. Roy Schafer, Staff Psychologist and Associate Clinical Professor of Psychiatry and Psychology at Yale University, generally agreed with Dr. Bromberg that something had affected Ruby's ability to control his own actions. At one point in his testimony, Dr. Schafer says of Jack Ruby, "He appears to feel not altogether in control of his body actions, as if they occur independently of his conscious will at times."

Dr. Manfred S. Guttmacher, Chief Medical Officer of the Supreme Court of Baltimore and one of the nation's leading experts on criminal psychology, was caught in a most confusing posture when he testified in good faith and quite accurately that Ruby's brain had been "damaged". It was clear that Guttmacher could not figure out exactly how. And since R.H.I.C. applied ineptly—as described on Ruby—leaves a set of medical clues different from any previously known, Guttmacher's confusion is understandable.

Dr. Guttmacher testified that he felt that Ruby at the time of the shooting had suffered a "functional

97

psychosis". "It would be functional, not organic," said Dr. Guttmacher.

Assistant District Attorney Bill Alexander asked, "Well, by functional mental psychosis, do you mean a psychotic condition for which there is no known organic cause?"

"Yes".

"Doctor", Alexander protested, "aren't you shooting both barrels at us? On one hand, you say that he's got brain damage, and then you say, no, he does not have brain damage . . ."

11.

A Lawyer Is Disturbed

One rather tragic side-effect of the Belli defense of Ruby still haunts the distinguished lawyer.

Belli correctly guessed that the motivation for the act of killing Oswald came from some kind of strange manifestation of Ruby's brain that could not easily be accounted for. This was a sensitive and extraordinarily perceptive diagnosis. It was the correct diagnosis . . . but it was to prove only a stumbling block to the Ruby defense. As all America watched the first Ruby trial, professional and sideline amateurs all second-guessed Belli and wondered why he had chosen this seemingly weak and con-

fusing defense for his client. Why hadn't he let Ruby testify?

To his everlasting credit, this veritable legal genius somehow sensed that beneath Ruby's conscious mind there was a subconscious block to his effectively testifying. Only an objective clinical view of Ruby's mental processes as seen from the outside could really help.

Well, the method was, as it proved, ineffective. For what little satisfaction it may be to Melvin Belli, as he reads this report, he can at least consider that he was almost alone in sensing the presence of R.H.I.C. He correctly fingered the villain . . . but the shadows of The Rumor were simply too deep for him to penetrate to what now seems to be the only truth.

The testimony that Belli relied upon, the evidence of "something" that affected Ruby's brain—as clearly indicated by a study of his electroencephalographic patterns—seems at every step to substantiate The Rumor.

Ruby's "block" about Oswald's name seems to substantiate The Rumor. His otherwise inexplicable behavior before he killed Oswald seems to substantiate The Rumor.

According to his testimony, Ruby remembered only one phone call before he left his apartment that fateful day he killed Oswald.

The call he remembered came from one of his em-

ployees, "Little Lynn," asking him to telegraph some urgently needed funds. The call he did not remember evidently came a few seconds before her call. This was the phone call that gave him the long indoctrinated command to kill Oswald and then completely forget the phone call.

The misuse of the R.H.I.C. procedure . . . which according to The Rumor did indeed damage Ruby's brain to some extent . . . also nullified the perfection of the technique itself. R.H.I.C. didn't quite work on Ruby the way it should have. As we have pointed out, under hypnosis (evidently for quite a while) he overheard idle conversation between members of The Group while he was supposed to be "resting" or the implantation was taking place. This conversation, which had to do with the sinister Nazi-like aspects of The Group's thinking, remained in Ruby's subconscious and surfaced in a weird way later in something he wrote, *which you will now read here for the first time!*

In some authenticated private correspondence this author had brief access to, Ruby wrote ". Remember everything and destroy same . . ." Later, ". to start my story off, they found some very clever means and ways to trick me." And still later: "*I was used to silence Oswald.* I walked into a trap the moment I walked down that ramp Sunday morning."

He continues writing to his correspondent, "The

reason I have gone through all, the explanation is, that knowing of my complete innocence and their framing me as they have, there certainly was a *tremendous motive* for it."

Evidently referring to the conversations that he heard under hypnosis and remembered now despite the haze of planned post-hypnotic repression . . . he puts the finger on a Nazi-inspired group and neatly substantiates The Rumor with these phrases:

"The old war lords are going to come back. S. A. [South America] is full of these Nazis!" And then . . . "They will know that is only one kind of people that would do such a thing . . . that would have to be the Nazis and that is who *is in power.*" He concludes this document, which he was certain at the time would be destroyed as he requested, "The rest depends upon you, you can be of some help some way. Be careful . . . they are after my blood. See if my prediction will be correct."

The "they" Jack Ruby refers to would seem to be The Group, and the oblique mentions of South America and the Nazis would seem to indicate that he somehow unconsciously understood much of the methods and motives of those who controlled him.

It is pathetically significant that in both of these lengthy private communications, which the author saw, Ruby inadvertently refers to something which would be very unimportant were it not for the fact that it represented the moment that he received the

final order to kill. It is as if he wants to block this truth from his mind, by denying it to people who haven't even questioned it.

"Why," he asks in the same correspondence (for no aparent reason), "would I have accepted a phone call at 10:50 a.m. at my apartment from a girl? A man that had planned something that Sunday morning don't accept phone calls ... try and *remember* all this."

What Ruby is *trying* to say in fact is that he is trying to *forget* one of those phone calls. In the other communication, he stresses that the "phone call would not fit into a plan."

He, all his living days, even in a death-bed tape recording tried to forget one of those phone calls, for it represented the moment that he was placed under control to commit murder.

And so, we must consider this fact while assaying the validity of The Rumor.

There were *three men* in Dallas that day who were the key figures in the enigma. Oswald and Kennedy are gone. The last one to die . . . in a *secret* and *private* missile that he instructed be *destroyed upon reading*, stated his conviction that he was used by a group using "clever ways and means" . . . to "silence Oswald" . . . and there was a "tremendous motive for it."

The Jack Ruby portion of our investigation adds its own striking dimension to The Rumor!!

ARTY UNITY: Gov. William W. Scranton of Pennsylvania and Governor
at news conference, held in Mr. Rockefeller's office, 22 West 55th Street.

COUNCIL APPROVES NON-LATIN FORMS FOR SACRAMENTS

Authorizes Bishops to Use Vernacular—Statement on Jews Is Put Off

By MILTON BRACKER
Special to The New York Times

ROME, Nov. 21—The Ecumenical Council authorized today the use of vernacular languages—English in the United States—for the Roman Catholic sacraments.

The move included even the essential key phrase of each sacrament. By an earlier vote, this was to be retained in Latin.

For example, when the latest decision is fully implemented, the phrase "Ego te absolvo a peccatis tuis in nomine Patris et Filii et Spiritus Sancti" in the sacrament of penance may be spoken by the priest in English. ("I absolve thee from thy sins in the name of the Father and of the Son and of the Holy Spirit.")

Move on Unity Advanced

The latest victory for liturgical reform—expected to be the first formally promulgated by the Council, at a public or plenary session next Friday—came on a day of other important procedural developments. These included:

¶Council approval of the first three chapters of the schema on ecumenism, or the movement toward unity among Christians, as a basis for discussion.

¶Announcement by the moderators or rotating chairmen that separate votes would be taken at an unspecified date on Chapters 1 and 3. These deal respectively with the relations between Roman Catholics and Jews, and with religious liberty.

While it was anticipated that this change did not constitute a "settling" of the two chapters as one church not strongly favorable to them put it, it was acknowledged that there was a possibility that on them might be a different session of the Council next session of the Council. Should this be the case, it would be a disappointment to the proponents.

¶Authorization by Pope Paul VI through the Council secretariat of a broad reorganization of the system of conciliar commissions.

Chairman Unaffected

The overall effect of the changes will be to increase the membership of the commissions.

Congo Ousts Soviet Aides; Suspends Ties to Moscow

Entire Embassy Staff Is Told to Leave —Adoula Asserts Diplomats Sought to Undermine His Regime

Special to The New York Times

LEOPOLDVILLE, the Congo, Nov. 21—The Congolese Government in effect suspended diplomatic relations with the Soviet Union today. It ordered the expulsion of the entire 100-member staff of the Soviet Embassy, including the two diplomats who were arrested Tuesday.

An official Congolese announcement said the two diplomats and another Russian who was arrested, a correspondent of the Soviet press agency Novosty, were released this afternoon. The two diplomats were ordered to leave within 48 hours.

Premier Cyrille Adoula said at a press conference that documents found in the possession of the two Russians proved that they were working with a "National Liberation Committee" formed in Brazzaville by

Christophe Gbenye, who was a supporter of the late Patrice Lumumba.

Mr. Lumumba was the first Premier of the Congo and his regime was strongly supported by the Soviet Union.

Mr. Adoula said that among the documents found on the Soviet diplomats was a letter from Mr. Gbenye's committee to a member of the Soviet Embassy in Leopoldville asking for money. Congolese francs (about $29,400) in forged bills, arms, tape recorders and other equipment.

"All these documents prove irrefutably the collusion of the Soviet Embassy in the Congo with this committee, composed of a handful of Congolese agitators who style themselves as

Continued on Page 11, Column 1

DEFENDS PURCHASE

Rockefeller to Avoid Pennsylvania Drive For Delegates Now

Goading in Deal He Aided—He Aided—Away Profit

SHANAHAN
Special to The New York Times
N. Nov. 21

By BERNARD STENGREN
Governor Rockefeller agreed yesterday that the need for Republican party unity in Pennsylvania took precedence now over his quest for delegate votes at the party's Presidential nominating convention next year.

At an 80-minute meeting in his office here at 22 West 55th Street, Rockefeller promised that he would not attempt to seek control from the major stock exchange outlets in Pennsylvania, changing and the filing for bank delegates "without consultation and agreeing with Governor Scranton."

The two Governors disclosed plans for the meeting.

Governor Scranton had said he planned to keep his state's delegation neutral until the convention opens in July.

At the news conference he stressed repeatedly that party unity was vital if the Republicans were to win state and local offices in Pennsylvania and elect their state's Presidential nominee.

"We are still in the minority party in Pennsylvania,"

LOST SOYBEAN OIL PUZZLES WALL ST.

Exporter Charges That Tons of Commodity Are Missing —Stock Prices Plunge

By H. J. MAIDENBERG

The alleged disappearance of millions of pounds of soybean oil sent tremors through Wall Street yesterday as two major commodity-trading houses suspended.

Yesterday, the Bunge Corporation, a major commodity exporter, charged that part of a supply of crude, degummed soybean oil stored in Bayonne, N. J., was missing.

Bunge had extended credit to the Allied Crude Vegetable Oil and Refining Company in Bayonne in return for security of the stored soybean oil.

Exporter Files Suit

The exporter filed suit yesterday to prohibit the removal of

Erhard, in Paris, Stresses Benefits of Link With U.S.

By DREW MIDDLETON
Special to The New York Times

PARIS, Nov. 21—Dr. Ludwig Erhard, West Germany's new Chancellor, arrived in the French capital today proclaiming that a close Atlantic partnership was valuable to both France and West Germany.

This allusion to West Germany's interest in maintaining intimate ties with the United States as well as with France was expected by diplomats to set the tone for the Chancellor's talks with President de Gaulle. Erhard is Dr. Erhard's first visit to France as Chancellor.

The French President let his feel and privately to 99 minutes this meeting and then had another discussion late afternoon. A third meeting, attended by ministers and advisers, will be held tomorrow morning.

Meeting Termed Cordial

French sources said the talks had been conducted in an atmosphere of cordiality and courtesy. A remark by Dr. Erhard when he boasted General de Gaulle at luncheon as to be nearer the mark.

U.S. SCALES DOWN HELP TO INDONESIA

Shipments of Plane Parts Halted to Prod Sukarno on Malaysia Issue

By E. W. KENWORTHY

WASHINGTON, Nov. 21—The United States has ordered the shipment of weapons and ammunition to Indonesia as an expression of its strong views about President Sukarno's hostile attitude toward Malaysia.

The action, taken last September, came to light today. It was taken quietly and without publicity, apparently in the hope that the Indonesian President might reconsider his attitude.

In the early edition of Nov. 22, 1963, before news of the Kennedy assassination, the New York Times called Tino de Angelis' non-existent vegetable oil, receipts for which he used as collateral for $150 million in bank loans, "the biggest mystery of the year."

12.

Allied and Tino De Angelis

The plan to utilize the R.H.I.C.-processed Lee Oswald to kill the President of the United States was a necessary part of the scheme to manipulate the New York Stock Exchange.

First, according to The Rumor, one or more R.H.I.C.-controlled persons had to be prepared for—and in a position to carry out—the assassination. The east coast had another team which would manipulate the expansion of a financial bubble whose burst would seriously upset the market. The two events had to be delicately synchronized to happen at the same time.

Were We Controlled?

According to The Rumor, Allied Crude Vegetable Oil Refining Corporation headed by Anthony (Tino) De Angelis was chosen to be the instrument to rock the very foundations of the world commodities market. Allied was chosen for a number of reasons. First, the commodities market does not lie in as much of the bright glare of public and press scrutiny as the traditional speculative common stocks which the average investor understands and follows more easily. Manipulation in this field (in which billions change hands yearly) seemed easier to The Group than the more glamorous and more closely observed areas.

Psychologically, Tino De Angelis was an ideal figure to propel upward like an ill-fated skyrocket. His ego and desire for power was matched only by cool courage . . . courage which had enabled him to survive the numerous crises and bluffs inherent in large commodities operations.

In our consideration of De Angelis and The Rumor, let us make it clear at the outset: the choice by The Group of Tino and his preparation as an instrument of the plan were *without* any conscious knowledge on Tino's part. Indeed, in retrospect, many of his later court room mutterings about failure brought about by "matters which were completely beyond my control" . . . seem to have been more tragically true than even he suspected.

The author must be frank in admitting that in

the handling of Tino De Angelis, as in the investigation by the Warren Commission, justice was more thorough than would appear at first glance.

When De Angelis finally was brought to the bench, Judge Wortendyke invoked a seldom used section of the criminal code to ascertain whether some unusual factors had influenced De Angelis' actions. In doing this, he showed rare intuition and judgment. Without the slightest hint of the ultra-sophisticated spider web in which De Angelis was caught, the good judge sensed that something was amiss here: the seemingly obvious swindle was somehow . . . a little *unreal*.

The judge used Section 4208 of the code which allows a judge to order a complete study of the criminal's actions and motives after first sentencing him to a jail term. The motive, Judge Wortendyke correctly decided, was missing. If this sounds odd— if criminal profits seem to have been obviously the motivating factor—consider the Allied story most carefully.

Allied was chosen by The Group because they felt De Angelis could be psychologically driven to the financial brink—and with him a good part of the commodities market. There was a large and diffused group of banks and corporations who were involved with Allied. When Allied finally went under, *fifty-one* were to suffer some form of financial injury because of direct business dealings with

De Angelis. With so many involved, a pattern of design would be hard to detect. The whole picture, they felt (and rightly) would be hopelessly complicated!

The second major reason Allied was chosen by The Group, was the fact that a large portion of Allied's structural support came from the Bunge Corporation, whose family roots were in Argentina where part of The Group's original strength lay.

The manipulation of certain Bunge officials, like the manipulation of De Angelis, was *without their knowledge*. The use of R.H.I.C. on selected persons is not a control of which they are conscious. Therefore, if two or three men were so manipulated, it must be in fairness pointed out, they simply did not know it! Both corporations, executives and employees, were therefore guiltless insofar as any knowing connection with the events in Dallas was concerned.

What of the key figures at Allied?

Anthony ("Call me Tino—everyone does") De Angelis, born in 1915, was the son of Italian immigrants who had settled in the Bronx in a cold-water flat in a tenement building. His father, a railroad worker, was a gentle hard-working man whose limited ability to bring home weekly cash was counterbalanced by his optimistic warm loving nature. For Tino and his three sisters and a brother, the father fairly radiated belief that America would

eventually fulfill the promise he had foreseen in it when he applied for citizenship. It was hard going but the De Angelis family were made of strong stuff. Tino did not take the easy way. He worked as hard as a man can work and came home at night to parents who, he claimed, taught him to "love and understand and to try to spread happiness, friendship, loyalty and brotherhood."

In an odd way, he accomplished those aims. For almost until the end, he was surrounded by an organization of fanatically loyal employees who were paid abundantly and often found themselves the recipients of lavish gifts. Tino's troubles were to come from his business competition (in a bitterly competitive field) and bureaucratic redtape (almost every business man's complaint), but seldom disloyalty within his own group.

His start was humble but respectable enough. In a job at a meat and fish market, he labored strenuously for long hours while some of the other boys on the block toyed with petty burglary and bookmaking.

By virtue of a fanatical devotion to his tasks, he found, by the time he was barely old enough to vote, he had one hundred and eighty employees under him. He had been promoted successively from a lowly helper to the position of manager.

He progressed to a job as foreman in an even larger firm, the City Provision Company, one of

109

the largest hog-processers in the Bronx. He established himself by sheer strength and physical skill as an outstanding expert with the cleaver.

In 1938, he formed M. & D. Hog Cutters and within three years, he was making a profit of over $250,000.00 a year.

During the war years, he multiplied his profits and began to devote himself to diverting some of his new found wealth into charitable channels. With his ever-present flair for the practical, he began to finance the training and assignment of seeing-eye dogs to the blind who could not afford them.

With the arrival of peace time, Tino De Angelis felt it was time for him to expand even further. He formed the De Angelis Packing Company. He shifted his operations and living quarters to New Jersey and located his plant in North Bergen, New Jersey. Here 250 employees worked under his banner.

By 1948, Tino, now thirty-four years old, was ready to make his big reach for total acceptance in his field. The Adolph Gobel Company was a very widely known meat packing firm which packaged a "name" line of food products in the New York area. Listed on the American Stock Exchange, Gobel represented a more complex and sophisticated kind of operation than Tino had previously handled.

Tino, it would seem, in retrospect, was a magnificent trader but a dubious account keeper. He had, it would appear, a kind of airy disregard for the

small print of life. As long as the main goal was achieved and everybody made money, Tino was happy.

Unlike the others who chronicled the De Angelis adventure, the author does not hold the opinion that Tino was deliberately disregarding the legal boundaries in his flight to business glory. Prior to Allied, which is an entirely separate affair, his entanglements appear a little more like bumbling than deliberate villainy.

Over and over, he found himself in trouble over fiscal and accounting department carelessness . . . rather than clever off-center manipulating.

As President of Gobel, while handling a smoked meat Federal lunch program, Tino was charged by the government with misstating weights to the tune of a $31,000 error. On the surface, this seems like an enormous bit of chiselling. However, the contract for the meat entailed the sale of 18,900,000 pounds of meat. De Angelis and Gobel were fined for this.

The second infraction involved some specifications for the meat laid down by the government and disputed by Tino on the basis that it would have put insufficiently cooked meat on school children's tables. The two fines came to a total of $100,000. This hardly seems profitable "operating".

Gobel was again in hot water in 1953. Now the problem was an inaccurate loss statement. This and

111

other contrived or sloppily encountered crises found
Gobel plunged in bankruptcy . . . with Tino out
of the President's chair until 1958.

There is much to indicate that success-driven Tino
wheeled and dealed at such a pace that the fact
didn't always catch up with the promise. De Angelis
seemed to make his errors regularly, but they ap-
peared to be at considerable cost to himself and not
with all the criminal design that has been so often
attributed to him.

Considering how fast he went up . . . and what
heights he reached in that hurry . . . he made a
"normal" quota of errors and misjudgments. After
all, he would often wryly comment, the government
obtained "the usual damage payments from him."
Everything up until the Allied debacle, all of Tino's
hits and misses, make him look a bit shady—but
. . . The "but" is a big one. An examination of the
record of the major meat packers indicates that he
did not have a monopoly on such weakness. How-
ever one-man shows like Tino's attract an inordinate
amount of jealousy and attention.

It is very significant that the one area where De
Angelis would have been criticized in retrospect by
his many critics if possible was the area of black
market meat operations during World War II.

If they have any concrete proof of such activities
by De Angelis (a natural first step for the kind of
villain they now try to paint him), they are certainly

112

very shy about displaying it. At least one report on De Angelis says that such allegations were whispered privately but charges were "never brought against him". In view of the fact that after the Allied scandal burst, the microscopic examination of his life was so thorough that one expected old parking tickets to pop up, it can be assumed that if they could have hung him with this one, they would have!

This rather detailed report on Tino's past demonstrates why he was an ideal man to select for control once he reached the stage of his life where he formed the Allied Crude Vegetable Oil Refining Corporation. He was by that time known as an absolutely brilliant promoter and trader quite capable of proposing and closing the very biggest deal imaginable. He had a proven track record of incredibly and rather obviously sloppy bookkeeping and quality control . . . none of which had proven serious beyond some nominal fines or rebates and legal tongue-lashings. In short, he was—allegorically speaking— the guy who drove the biggest car in town, the fastest, and admittedly constantly scraped the fenders.

13

De Angelis: Into The Past

Norman C. Miller's brilliant reports on Tino for the *Wall Street Journal* accurately caught the moral essence of so much of his life and times. The greedy fast-buck boys of the most imposing of our business institutions just found him irresistible despite the speed at which he propelled them.

(Miller has since written a book on Tino which is a classic of analysis and is a must reading for anyone interested in The Rumor.)

It was in 1954 that Tino De Angelis came to the attention in Germany of The Group that was to figure in The Rumor.

Were We Controlled?

Tino was involved in answering a complaint from the German Government that it had received inferior lard as part of a shipment. Word circulated in various circles in Berlin concerning the free-swinging De Angelis who was announcing that he would soon start a great new company which would be concerned with edible vegetable oils, a huge new item for U.S. export to underdeveloped countries.

As he had predicted, late in 1955, De Angelis and twenty of his most trusted co-workers started the Allied Crude Vegetable Oil Refining Corporation in Bayonne, New Jersey.

Although it was the last thing that he could have foreseen, the formation of Allied fitted The Group's plans and led inevitably to his complete financial ruin—and their profit!

If, for a second, you find it hard to believe that a small group operating out of a German headquarters could find it sufficiently profitable to plot the long term expansion and deflation of a financial bubble fathered by a Bronx butcher with dreams of glory, think again.

The chips in the importing and export of edible oils (especially, after the enactment of U.S. Public Law 480—the Food for Peace Program) were expensive chips. Our government's aim to send surplus grain and oil to underprivileged nations was noble. It was a plan, however, that was vulnerable to some

really top flight international manipulating by a team of the calibre of The Group.

Now, in his new position, and with the large oil storage tanks he had acquired in Bayonne, Tino De Angelis was the perfect American pawn for those manipulations.

It may have been that the "grain caper" was the one that whetted the appetite and provided the pocket money for Operation Control.

Briefly, here is an outline of the "grain caper": $55,000,000 worth of barley, corn and sorghum was to be shipped to Austria for German and Austrian firms by half a dozen American exporters. Somehow less than half of it got there! How do you lose $30,000,000 worth of grain? You do it, it turns out, with a carefully thought out international control operation with numerous dummy corporations and Swiss bank accounts and at least one German firm in Hamburg (which was a big new customer of a man named Tino De Angelis). In the course of a vast investigation of this little incident by the U.S., Senator Williams of Delaware set the probable "take" by the conspirators behind it at between three and five million dollars.

With this kind of "walking around" money and with the scent of financial blood fresh to their senses, The Group went to work with great precision on Tino De Angelis.

Tino, who had erased the shame of his Gobel de-

throning and had proudly hung up the banner of Allied, was ready for big things. To accomplish those things he needed the kind of customer that the Bunge Corporation typified.

It was at this point that the Bunge Corporation may have been chosen as the innocent corporate tool to implement the execution of The Group's plan. Its good will was essential to the business destiny of Allied!

Of the fifty-one companies which either lent money to Allied or deposited oil at its Bayonne plant against warehouse receipts, the Bunge Corporation was the one most critically attached to its fate.

When Allied's ship of destiny was steered into the deep waters, as indeed it was by an amazing series of maneuvers, only one collision was needed to sink it instantly to the bottom. A collision with Bunge Corporation would suffice . . . creating a disaster that would take with it the investment of the other fifty companies.

The Bunge Corporation (sometimes dubbed by financial writers as "The Octopus") would make a delightful corporate villain for a James Bond fantasy, were it a creation of imagination and had Fleming written its dialogue. In all fairness, however, the only thing about Bunge that recalls 007's formidable organization-opponents is its size and power.

We Americans generally feel we are knowledge-

able about the financial giants that tower over our lives. We nod knowingly and even respectfully when names like "DuPont," "GM" and "Standard Oil" drift across our conversational paths. We (grudgingly or not) respect the tremendous power of the gold that changes hands under these feudal banners. But Bunge . . . ? Now, that is something else.

Unless you are in the grain business or fats and oils, it's very anonymous indeed.

In terms of dollars and cents annual business, Bunge does rather impressively with two *billion* dollars worth of annual business in some eighty countries! One hundred and ten offices, linked in a most extraordinary manner by leased channels, Telex and private . . . remember *private* . . . under-the-ocean telegraph channels. The bill for communications alone is rumored to be $500,000 a year!

The kind of market maneuvering that was planned by The Group called for the utmost in communication facility, utilizing the most private, lightning-fast means. Quite aside from the cost involved, setting up such a network was impossible for The Group to do without leaving a broad trail of clues. They had to find and control some members of an already operating import-export organization which had at its command the necessary equipment and procedure "chains". In all the world, Bunge—because second-by-second fluctuations of the world market made or lost it millions—possessed one of

119

the finest communications networks outside of any government. RCA Communications, a little taken aback at the incredible assignments it fulfilled for Bunge, issued a publication about the Bunge Corporation entitled "Modern Global Communications Meet The Challenge."

The American Bunge Corporation is a privately held giant, financially controlled by a group of share-holders whose headquarters is in Argentina and is known as "Bunge and Born, Lda."!

The consistently Germanic tone in the structure of The Rumor finds a familiar echo in a profile of Bunge in *Business Week* of October 19, 1963. Here are two quotations from a well researched article about a company that gets very little publicity.

"While the company is still close-mouthed about financial affairs, members of the Born family in Argentina are believed to be the biggest shareholders." The Bunge and Born founders immigrated from Europe to Argentina.

And later . . . "Directors are mostly naturalized immigrants or second generation Argentinians of Belgian and German descent. Director Leon Mainzer, for example, immigrated from Germany . . ."

It is not our intention to indulge in a smear-by-inference tactic by our repetition of the recurring "German" note. Mainzer's name indicates to us nothing more or less than that to attain such a post in such a company the man must be a brilliant ex-

ecutive with a keen business mind. The point we are making should be very clear indeed. If we are to explore The Rumor as it is, we must accept one very basic fact. Mr. One and his companions (and they were probably very few in number—perhaps fewer than five) were mostly German. In choosing a large corporation dealing with Allied, The Group would simply find it easier to select men they could approach on a social basis—and place under R.H.I.C. without arousing their suspicion—if they spoke German.

Bunge had everything: a German influence in its home base of Argentina, supra-flexibility in world communications, tremendous assets, and a strong influence on and connection with Allied and Tino De Angelis.

Bunge, like Allied and Tino De Angelis, had nothing to gain and everything to lose by an involvement with The Group. This, however, was of no consequence to those individuals who planned one of the most incredible ways of acquiring half a billion dollars ever conceived by the minds of men. And so it was without their knowledge that Bunge and Tino were controlled to play their part in the execution of the crime without the slightest awareness they were being "used".

That Bunge support was critical to Allied cannot be argued.

Were We Controlled?

On April 21, 1964, before the referee in bankruptcy, De Angelis was later to testify.

> Question (by David Ravin of Ravin & Ravin):
> "What percentage of Allied's business, as far as exporting is concerned, did Bunge have?"
> Answer (by Tino De Angelis):
> "Possibly 40%."
> Question:
> "And what did the next highest have?"
> De Angelis:
> "Maybe ten or fifteen percent . . ."

In moving into the new fields of edible oil storage and sales, De Angelis opposed the powerful midwestern "crushers" who processed by crushing cotton and soybeans into the makings of foodstuffs. Using the Gulf of Mexico as a shipping point, they fed the world's supply down the Mississippi for the port-pick-up by tankers.

The ever present threat that these midwestern groups might some day abandon their trade connection with the import-export groups which sold the oils from New York—and try to deal directly from the midwest — helped establish the surface link between Bunge Corporation and Allied.

Because Allied was quickly established as the "cheapest source of supply," as Bunge's American head put it, Bunge went "all the way" with Tino

De Angelis . . . (or, was it because someone at Bunge was "controlled" unknowingly almost from the outset of the business arrangement?).

Soon Bunge and Allied seemed to be getting along famously. Bunge exported about 100 million dollars worth of vegetable oil each year and Tino De Angelis' Allied supplied most of it.

Where did the financing for this operation, which was a bit heady for the Bronx hog-cutter, come from?

Well, Bunge lent Allied up to twenty million dollars at a time (holding warehouse receipts) in order that De Angelis could get the raw materials he needed to operate.

The most interesting and revealing factor is that Bunge used its own money to finance De Angelis instead of resorting to bank loans.

Going even further in its paternal interest in De Angelis' business affairs, Bunge allowed De Angelis to really take off into financial outer space . . . by pledging at one point as much as thirty-eight shares of the hundred odd shares of Allied stock and other De Angelis stock for huge loans. Someone in Bunge supported him in his efforts to play king. Others, like Karl Groenfeld, Senior Traffic Manager for Bunge, were suspicious.

The two companies frequently conferred on a price to be submitted abroad on foreign orders. Bunge, the giant, reached down and lent its strength to Tino's growing firm. Was this perhaps upon the

advice of one or more within Bunge who were controlled?

Bunge was by no means blind to the facts of life when the operations of The Group started to use Tino's little empire in illegal ways. Bunge executives were quick enough to descend upon Bayonne in 1962 to check on a rumor that some of the oil they held receipts for was simply not in the tanks. These executives and others had questions—many questions—many times—during the wedding and marriage of Allied and Bunge. Was someone within Bunge covering over and smoothing out the difficulties so that the two could be led to the edge of the financial cliff? There is some reason for consideration of this thought . . . which would, of course, add considerable weight to The Rumor! That person or those persons at Bunge, Tino De Angelis at Allied, and Lee Harvey Oswald in Texas—all innocent R.H.I.C. tools—formed the understructure of The Rumor!

14.

Operation Control!

It was spring of 1961. The instruments of control were now all placed on the chessboard of the world scene, ready to be moved by The Group to consummate their plan.

Lee Oswald and Marina were in Moscow and were ordered to apply for visas to go to the United States.

Was control by R.H.I.C. in force on at least one unsuspecting person in the Bunge Corporation?

If R.H.I.C. control was present in Allied—with

Tino himself or a most trusted advisor under total R.H.I.C. manipulation—the time was ripe.

Dallas at this point was not the target city . . . not yet.

Lee Oswald was the designated "official" assassin and it was important that he be back in America now . . . for the time-table of Allied's artificial expansion and eventual financial bust was a matter of delicate timing, and to put it bluntly . . . when it did topple, there was a President to be assassinated *immediately.*

It was, of course, all a matter of months away . . . but it was a deed that already cast its shadow ahead.

In May of 1961, Lee Oswald was directed under control to start the wheels turning that would facilitate his return to the United States. This he did (Warren Exhibit 973). Both he and Marina visited the U.S. Embassy in July for an entry visa and simultaneously requested that the USSR Ministry of Foreign Affairs grant an exit visa. It would take time, but then so would it take time to propel Allied and Tino De Angelis up to dizzying heights of financial jeopardy.

Mr. One received confirmation from an undercover associate in Russia that the visas would all be worked out and in the month that followed, the trap was carefully sprung on Tino De Angelis. This trap was to place him and Allied in such a position

that he would almost pathologically destroy Allied and himself financially. In so doing, he would provide The Group with the kind of working capital that they would need to sell the collapsing Allied short on the commodity market when its eventual drop would be further panicked by the deliberate assassination of the President! The prospective profit to The Group was calculated to be ONE BILLION DOLLARS. (Evenly split up amongst a dozen members, it was the kind of lure that men sell souls for). In fact, it probably netted about half a billion.

It must be carefully considered that if R.H.I.C. controls were in force on Tino and a Bunge official and on Oswald, there was really no reason for the plan not to work. The susceptibility of the market to the kind of scandalous collapse planned for Allied was well known. If the announcement could be made suddenly, the market would drop sharply. If the President were to be tragically murdered at that exact time the market would drop even *further*. It was fiendish . . . but logical!

The most fragile part of the plan lay in the marksmanship at the assassination scene and the elimination of Lee Oswald as soon after the assassination as possible.

It was never planned that the actual assassination would rest on Lee Oswald's ability to handle a rifle. It was important that he be apprehended or identified as the assassin so that the psychological pres-

sure of a "never-ending" world search would not make The Group's lush existence a very nervous one after the money was divided up.

In short, it was a workable plan, however scientifically sophisticated were the procedures and however desperately evil the methods.

A clock began to tick . . . a clock that was attached to a kind of time bomb that blew up something more precious than profits. It ended John F. Kennedy's dream of Camelot in a world where evil has acquired most of the options. It was, I suppose, inevitable that he and his wife, two young people on whose shoulders the dreams of so many rested, had come to a confrontation with a small group who represented the powers of darkness. Kennedy was an *exceptionally* strong symbol of strength in a wavering civilization. The Group was—as a unit— just as strong. Where he was cool and controlled, they were heartless and controlled. Where he thought as a young President in terms of tomorrow's dreams . . . they were not ashamed to use tomorrow's scientific tools for a horrendous project now!

In examining the structure of The Rumor again and again, the author could feel the tug of parallel influences which weighed against an easy dismissal of The Rumor as just a harmless nightmarish fantasy.

Over and over again, the damning fact seems to be that too many of these parallel incidents can be

explained *only* in terms of The Rumor. "Coincidence" becomes a mocking, leering clown's mask that keeps popping in front of us to haunt our research.

Summer of 1961 was the ideal time to propel Allied and De Angelis into a position where his back was to the wall. Then his very survival would appear to rest upon his taking gambles beyond all of his previous concepts.

Up until this point, De Angelis' mistakes in operating Allied had been mostly of the careless, sloppy type that had characterized his operation of Gobel. There was rain water in the oil storage tanks. Sometimes, the inventory on hand did not seem to match the receipts for loans and, in general, free-wheeling Tino was running true to form.

The brilliant trading was still in evidence and Allied was by no means anything at this point but an exciting business success story which had raised the sights of Tino's ego even higher. During 1961, $166,600,000 was deposited to Tino's firm at the First National Bank of North Bergen.

Tino was led to believe that he had a sure order from Spain for *275 million pounds of soybean oil!* Payment for this would have amounted to thirty-six and a half million dollars!

Heady brew indeed for the hog-cutter from the Bronx!

So, of course, began the inevitable build-up of Allied for the big let-down. In his Bayonne tanks, De Angelis had about fifty million pounds of oil. That left 225 million pounds for Allied to acquire in the future.

Tino turned to the Chicago Board of Trade, with a supposed Spanish "promise" of eventual payment in *American dollars.* (Were he not controlled, this alone would have alerted him to take a second look at the deal.) Tino started dealing. . . . Allied is said to have closed over 3,000 separate contracts for 180 million pounds of oil. If the sale to Spain were not consummated, he would have to put forth 18 million dollars for these orders. And even a half-cent a pound drop in the futures price (if it occurred before delivery date) would mean that De Angelis would have to produce almost a *million dollars* more within twenty-four hours to meet the margin regulations of the Exchange.

The Spanish deal, of course, as it had been controlled from the start . . . *vanished into thin air* . . . leaving Tino sitting on top of the soybean world in an almost insane predicament.

This was contrived to force him into a position of bluffing and to appear to those around him to have a reason for such action.

Tino, in a decision that may very well have been R.H.I.C. implanted, announced that he would *keep* the futures contracts he had purchased . . . because

surely there was some "mistake" and the Spanish buyers would reconsider.

Further bolstering him publicly in this precarious stand, as luck would have it, the Agriculture Department predicted record exports of vegetable oils for the upcoming year of 1962.

The forecast proved over-optimistic and downward revisions of these prospects were made periodically through the ensuing months.

What followed was fantastic! As unreal as anything that is part of The Rumor is *for a moment* to believe that anyone (Spanish or otherwise) can just ease out of a 36.5 million dollar deal and leave the other party stuck for 18 million dollars with no recourse. The answer perhaps is that without a shred of basis, De Angelis was controlled to *believe* that he had such a deal. This belief presumably was implanted under R.H.I.C., causing De Angelis to undertake certain negotiations which later lent an aura of reasonableness to his claim that his enemies were plotting against him and the deal had vanished into thin air. Other men in the same business have since expressed doubt when questioned on this point that there ever really could have been a deal of this magnitude where the "change of mind" about such an order would not have left an easy avenue of legal recourse.

According to all reports, there was no such re-

course attempted. Reports that he had hired a "battery of lawyers in Madrid" never were followed by any glad tidings.

The catastrophic situation that Allied found itself in was then magnified by a series of business maneuvers that will go down *as the most incredible of this century!*

Suddenly De Angelis started doing things that seemed compatible only with a plan for self-destruction. This kind of tendency had not marked his previous sky-rocketing years. It appeared there was some influence in control of his mind! Miller, in "The Salad Oil Swindle" states: "He increased his purchases of future contracts far beyond the needs of his legitimate export business. His future purchases could not be considered hedges against vegetable oil orders. The prospect of orders was dimming, not brightening. The orders existed only in Tino's ego-clouded mind".

Was his mind clouded by ego . . . or by R.H.I.C.?

Lest for a minute you consider that De Angelis was a simple little hustler who had gotten out of his depth and decided to turn to crooked means and damn the consequences, listen to this opinion of De Angelis by Morton Kamerman, Managing Partner of the brokerage house, Ira Haupt & Company.

"De Angelis had been in this business a long

time. He was the dominant factor in it. These bankers had seen his plant and liked it very much, thought he had a darned good operation. And, as far as risk was concerned, he had been in the business a long time and to stay in the commodity business and stay out of trouble for many years, meant that the fellow could not gamble."

. . . And yet, De Angelis set out, seemingly deliberately—or was it under the compulsion of R.H.I.C.—to destroy his reputation beyond any possible chance of repair . . . at a relatively young age!

Again, Miller on De Angelis, "Tino must have known his dream of cornering the futures market was hopeless". This casual phrase has significant depth if we reflect on the possibility of R.H.I.C. control. If in fact he "must have known," then he would have proceeded only if he were impelled by a force beyond the control of his conscious mind.

Mind you, it was not to save himself from a bankruptcy that he would commit financial hari-kari. He had survived the bankruptcy of Gobel and indeed done it rather well. It was not greed for sudden greatly expanded wealth. Norman Miller put it well when he wrote, "Tino was not one to hoard money. His basic interest in money was how it could further his reputation as an important person. He wanted to be known as a big shot in the

133

community, as well as in the commodity trade. Outside of business, he cherished his image as a respectable family man."

With this information on the man's make-up then, we are asked to believe (if we wish to dismiss The Rumor) that what Tino De Angelis did from this point on, he did while in conscious control of his actions. As you will see, it simply doesn't add up!

Tino started a strange new kind of activity. It was characteristic of all his behavior from that point on.

He started buying futures contracts, not on orders he had for Allied, but supposedly on contracts he might be going to get. To do this (in view of the fact that the Spanish debacle had put his back to the wall), he issued phoney warehouse receipts indicating he had stored in his huge Bayonne tanks . . . oil that did not exist! Was this just a little bluff that he thought he could cover up with one handsome deal over an afternoon lunch?

Hardly.

In retrospect, Justice Charles A. Loreto, in May of 1964, commented on this little lark of Tino's. (If we refute The Rumor, we presume that Tino made his deals consciously with the thought he could replace the missing oil with a handy truck delivery one moonlit night. The truth is that before Allied collapsed, 1.8 *billion* pounds of oil vanished.)

"The disappearance or non-existence of the stupendous quantity of 1.8 billion pounds of oil from the Allied tanks is one of the most extraordinary and startling occurrences in the mercantile world during this century . . .," said Justice Loreto.

The pyramiding of the dead-end futures buying continued at a frantic pace in October's first two weeks. Having just borrowed 2.5 million dollars from the famed brokerage house of Haupt, Tino was buying futures and paying wherever possible with warehouse receipts for oil that (as events later proved) either vanished or simply never existed. This was a one-way street to utter destruction for Allied.

15.

The Timing

If we are to believe The Rumor . . . the assassination was to be timed to coincide *exactly* with the collapse of Allied. "Controlled" Lee Oswald, the key man to front the actual shooting, had been chosen.

The two events now drew closer together.

Allied's erratic operation was becoming alarmingly noticeable. Its head-long careening along the financial highway could go on only for a few more weeks or months.

At this point, the decision was made to bring both sides of the parallel factors together for the big collision.

Consider carefully the fantastic timing of two crucial phases of the "collision course".

There was to come a point when all caution would be virtually abandoned for Tino and Allied. An "anything goes" course to bring in big cash had to be quickly followed. This point was reached when the date of the assassination had been selected . . . and the assassin was placed in the location to do the shooting!

It would seem that in the last part of September and early October, Dallas was chosen. The Depository area was chosen . . . and Oswald therefore had to be placed in that area. As soon as he was placed in that position, the New York operation could throw its switch and Allied and Tino and the whole commodities market could be placed square on a destruction course—but not *until* he was so placed!

On the morning of October 14th, a phone call from Dallas indicated to the "controllers" that Lee Harvey Oswald was locating on a job at that moment and would start that week at the Texas School Book Depository (Commission Exhibit 993). On the afternoon *of that same day*, Tino De Angelis threw all caution to the winds and sent (in a completely suicidal business gesture) the first forged American

Express Warehouse receipts for six million dollars worth of phantom oil to Wall Street. In the next few weeks, he sent an additional 33 million dollars worth of forged papers. It would seem as many were sent as could be absorbed by Wall Street before the assassination took place!

If there is truth to The Rumor, intelligent planning would have precluded throwing Allied's crash-for-money journey into high gear until the gunman was definitely placed at the scene. Astonishingly enough, the facts bear out that this is exactly what happened!

Bunge's position was now to change completely. Rather than support Allied with its strength, it now seemed to prepare to weaken it for the big crash. In early October, Tino requested an increase in loans from Bunge . . . and to his astonishment Bunge refused!

Simultaneously with the placing of the forged American Express paper in Wall Street (and directly upon the heels of Oswald's stepping into the Depository job), De Angelis started check-kiting on an unbelievable scale. From this point on Tino manipulated cashiers' checks for 17.5 million dollars. He was using Manufacturers Hanover and warehouse receipts for oil.

On Friday, November 15th, the whole fantastic net was drawn in a bit closer. According to Miller,

139

"Shortly before 2:00 p.m., short selling started to dominate the market. Rumors swept the trading floor that Bunge was behind the selling . . . "

Again from the same account of that day, Miller quotes Sam Ingal of Allied, as concluding that Bunge had "knocked the market apart".

As of the following Monday morning, De Angelis ("controlled" to wreck his own firm and the market along with it) had to be used to slow down the ultimate burst of the bubble. The parade through Dallas was at noon on Friday. Allied could not collapse completely until after the market closed on Thursday afternoon. What did The Group do?

Just about anything that would stall the inevitable.

On Monday, Tino wrote a personal check for over three hundred thousand dollars to cover a sum due Williston & Beane, a brokerage house he was heavily involved with. This would keep *them* quiet until about Thursday . . . when it would bounce. After that . . . well . . .?

A forged order for Bunge's oil in Tino's tanks was issued and American Express Warehouse unwittingly issued warehouse receipts for more than eleven million dollars to a brokerage firm which gave them to two banks, Continental Illinois and Chase Manhattan.

On the night of Monday the 18th, Morton Kamer-

man of Haupt noted, aghast, that that day's dropping futures prices had driven Allied's debt to Haupt from 9 million dollars up to 14 million. Kamerman called in his accountants for some late night emergency work. He simply could not conceive that there was any rational explanation for what was going on. He was right, of course. There was nothing at all rational about Tino's course of action . . . not unless he was "controlled"!

Kamerman called Tino on the telephone to demand a full explanation.

In "The Salad Oil Swindle", we learn that at this point (Monday night) "Tino was stalling. He didn't mention the bankruptcy papers his lawyer would begin filing with the Federal Court in Newark the next day."

There were three possible reasons for the stalling that Tino did until Thursday afternoon. One, he might have planned to rob Fort Knox and make good all his debts. (Nothing short of Fort Knox would have helped.) Two, he planned to fly to South America to escape-it-all and for some strange reason liked to fly only late in the week. Three, the full impact on the commodities market of his gigantic frauds had to be postponed until the day of John Kennedy's reception in Dallas on Friday!

On Tuesday, the 19th, Tino further stalled a realistic confrontation of the situation by refusing

141

to authorize Haupt to sell a big parcel of soybean oil futures at a loss.

Because Tino carefully hid from the financial world the fact that invalid warehouse receipts were about to rock the market to its foundation, a cautious inquiry into the entanglements of Williston & Beane and Haupt with Tino . . . kept the officials of The Exchange a bit worried, but not yet in a panic state.

At this point, a vice-president of Bunge warned American Express Warehouse to be on the alert.

Late in the afternoon, the news was received that Allied and two subsidiary companies had filed a bankruptcy petition!

Wednesday, November 20th, passed quietly but frantically as the officials of the Produce Exchange tried to put the pieces together. Haupt and Williston & Beane tried to reassure their nervous customers that all would be well. Tino seemed to be impossible to find that day.

Williston & Beane and Haupt were suspended by The Exchange.

Allied's bankruptcy as such was not as alarming as it might have been because most concerned thought that *their* large loans to Allied (certified by warehouse receipts for salad oil) left them in a secure position.

Daniel De Lear, the bankruptcy trustee, was far from asleep.

142

One of his key legal minds, Morris Ravin, caught wind of the empty tank possibility. When he found that Tino was, it would seem, in hiding, Ravin contacted the Department of Justice.

On Thursday afternoon it was important to the success of the "controllers" that the groundwork for a complete panic of the market be laid so that on the day of assassination, Friday, the prices would plummet and the profits reaped by selling short would be insured.

In considering whether The Rumor is truth or fantasy, one must note that of the fifty-odd companies that could have moved that day to lift the lid that would light the bomb . . . the one that *did* file suit (charging that American Express had "lost" 160,450,000 pounds of oil worth $14,240,000 at Allied through forged orders) was *not* Haupt, *not* Williston & Beane . . . but the Bunge Corporation!

Bunge's action blew the top off everything and laid the groundwork for the impact on the general public the next day.

On Friday, November 22nd, the target hour had been reached by the "controllers". The New York Stock Exchange unknowingly helped stagger the full impact of the Salad Oil Scandal until the afternoon by announcing that two outside brokerage firms anxious to help the general condition of the market had offered a joint half million dollar loan to Williston & Beane to enable them to meet the

net capital requirements of the Exchange. An announcement at 12:15 said that Williston & Beane were reinstated. Stock prices improved slightly. It was as if a bit of beautiful prizefighting tactics was being employed. The "victim" was set up by a left, ready to take the full impact on the chin of a knockout blow from the right.

That knock-out resulted from the plight of Haupt. Haupt's position presented the worst nightmare that Wall Street could conceive. Almost twenty-one thousand Americans had left stocks worth 450 million dollars in the safe-keeping of the concern. It, in turn, because of Allied's chicanery and bankruptcy found that it owed banks here and in Europe thirty-seven million dollars that it *could not pay!*

Haupt, immobilized by its suspension, could not return either money or securities to panicky customers. If it were placed in bankruptcy, years might elapse before the average investor could get back part or all of his investment.

16.

Stock Market Action

The good name of the Stock Exchange was in deep peril, but Keith Funston, the head of the Exchange, was not a weak man. He was determined to somehow find a solution without panicking the market more than was necessary.

He called an emergency meeting with Haupt bankers at the Exchange offices.

Just before they stepped through the doors, Lee Harvey Oswald . . . as he had been controlled to do . . . pulled one of the triggers in Dallas.

Were We Controlled?

The "controllers" group at various key spots in the financial market here and abroad was ready!

The "controllers," according to The Rumor, were able to divert approximately 200 million dollars from their normal channels in the Allied manipulations. This figure is borne out by the record.

By taking a "short" position in carefully scattered areas of the market (with full knowledge of an impending drop of possibly 30 points), they theoretically could have realized as a result of their murderous criminal conspiracy a profit in excess of six billion dollars. Actually, rumor has it, they brought in the more modest but still fantastic payoff of one half billion. *Five hundred million dollars!*

As the news of the President's assassination echoed across the floor of the Exchange, the stock market dropped (as it had been controlled to do) 24 points in 27 minutes. 2.6 million shares were sold off in the greatest panic the market had seen since 1929.

The hysteria was so great that the Board of Governors of the Exchange closed the Market down at 2:07 p.m., more than eighty minutes before normal closing time.

The "controllers" had hit their target right in the center. We lost a great leader . . . they made a huge criminal profit in selling short in many markets.

It did not go completely unnoticed . . . this odd coincidence of trouble.

146

Frederick Hediger, head of Garnac Grain, a major customer of Tino De Angelis' firm, is quoted in *True Magazine* as saying that when he heard on the radio that afternoon that "Kennedy had been assassinated, I thought this must be a plot by the Russians or the underworld—too many crazy things are happening at once." If The Rumor is true, Mr. Hediger's feeling was strikingly intuitive.

The New York State Attorney General's office considered the possibility that Tino had been "broken" in the futures market by someone who sold short and profited on a gigantic scale.

These men were not thinking about Dallas—just the Market. The controllers, aware both events were to coincide, were in a different position.

Their advance knowledge of the impending drop in the general market provided their terrible motive. That, according to The Rumor, is why John F. Kennedy had to die . . . No other single event (outside of a major war), controlled to coincide directly with the crash of Allied, would drive the market down so sharply in a single day of trading.

Later in court before Federal Judge Wortendyke, Tino De Angelis seemed hardly to know why he acted as he had.

Ironically, in one statement he issued while the long court sessions dragged on, he said, "The situation in which I find myself today is as a result of

conditions, *controls* and restrictions imposed upon the Commodity Market over which I had no control."

Tino's self-righteous confusion at first affronted everyone connected with the prosecution of his activities with Allied.

One wise man (who was to be criticized in some areas of the press for it) tried to see below the surface of Tino's dilemma.

This man was the very Federal judge before whom Tino stood in judgment. Judge Wortendyke studied the pre-sentencing report from a probation officer and announced that after extensive ". . . and conscientious consideration" of the officer's report, he still didn't understand De Angelis' motivations.

A wise and perceptive man indeed to sense that something out of the ordinary was driving Tino. The judge ordered a complete "study" by psychiatrists and other experts for a three month period. Tino was later sentenced to ten years.

Just as Jack Ruby was haunted by the faceless ghosts of control who ruined his life, so Tino De Angelis unwittingly revealed some of that same after-effect of being controlled.

In Document 649, in testimony before the Honorable Joseph Fishberg, in bankruptcy proceedings, on November 8, 1965, he said when referring to the exhaustive schedule of work he followed without complaint in the Federal prison,

"If I didn't work 14 hours (a day) *certain crazy thoughts* would run through my mind." [Author's emphasis.]

The ambitious hog-cutter from the Bronx had come a long way to a fantastic end. Was it because it was his fate to be one of us who was "controlled"?

17.

Tampering With The Time Sense

Earlier we considered the second tool of control: electronic dissolution of memory.

One by one, evidences of E.D.O.M. appear.

On September 25, 1963, a Harvey Oswald appeared at the Selective Service Board in Austin, Texas, for a 30-minute discussion of his dishonorable discharge (Commission Report page 732). On the same day, Lee Oswald was seen on a bus heading for Mexico (Report, pages 731-733). The second sighting was accepted by the Commission . . . but then when was he in Austin?

Were We Controlled?

Ordinarily, Lee Harvey Oswald did not drive a car. This has been accepted as fact. Under "control", Lee Harvey Oswald had been taught to and did, however, drive a car.

According to witnesses:

A. He drove to and from the Sports Drome Firing Range where he attracted attention to himself by firing at other persons' targets with his rifle—and also demonstrating an ability for markmanship.
At the time he was supposed to have been there, it was also a fact that he was at work or with his family. (When was Oswald at the firing range?)

B. In Alice, Texas, the Executive Director of Radio Station KPOY reported that he, Oswald, drove to see him and talked with him about half an hour. This happened on October 4th, a day that Lee Oswald was in Dallas. (Report on page 666). (When was Oswald in Alice?)

C. A Furniture and Gun Store in Irving, Texas, reported that on November 6th or 7th, Oswald and his family entered the store and discussed purchases and then left and *drove* off in the direction of a Specialized Gun

repair shop. This second store was the Irving Sports Store, where the clerk even made out a receipt to a man named Oswald. It is interesting to note that the authorities investigating the assassination were sent on a visit to the sports store by an anonymous telephone caller (Mr. One or his aide?).

D. A car salesman at a Ford-Lincoln showroom named Bogard had this strange story to tell about Lee Harvey Oswald (664; 685; 687; 702-3; and 26: 450-452):

On November 9th, according to Bogard (who by the corroborating witnesses and polygraph tests was later proved to be a reliable, honest witness) (26: 577-78): Lee and Bogard went out and Oswald test-drove a car at 70 miles an hour. He also talked of coming into large sums of money shortly. He told the credit manager that if he were not given credit, he would go back to Russia and buy a car. The Warren Commission satisfied itself that for certain (uncontrolled) Lee Harvey Oswald did not drive. They further noted that on November 9th, he was in Irving writing a letter to the Soviet Embassy. (When was he at the car agency?)

E. On November 20th, at 10:00 a.m. (when

153

Lee Harvey Oswald was at work) a "Lee Oswald" was reported at the Dobbs House Restaurant in North Beckley in a report by a waitress (26: 516). He made a considerable fuss about his food and was easy to remember (When was he at the restaurant?)

F. When Oswald was in Mexico, he was reported in Irving (on November 8th—Commission reference 26: 178-179; 10: 327-340) cashing a check for $189.00 in a grocery store and visiting a barber shop making "leftist" remarks. The barber noted that he had seen Oswald *driving* and entering the other store.
(If Oswald was in Mexico at this time (10: 309-327), when was he at the two stores in Irving? It is important to note that Marina insists she was never at these places and Lee did not drive!)

If Lee was, as The Rumor has it, a "controlled" person—and if he was directed to sometimes carry a small E.D.O.M. device with him which distorted time conception and destroyed the reliability of the time-sense of the people he saw—The Rumor then explains what is now unexplainable in the assassination.

154

If Lee Oswald, who was under "control" for a considerable period of time, was taught to drive a car under control but was told to *forget* this fact consciously . . . The Rumor would again explain the unexplainable!

Richard H. Popkin, in his truly superb piece on the assassination in *The New York Review of Books*, notes: ". . . The Warren Commission dismissed all these incidents as mistaken identification . . . " Then later, "One gets the impression that the hard pressed staff found it convenient to ascribe all the incidents to *tricks of memory* and *other aberrations* [author's emphasis], notwithstanding the fact that many witnesses were apparently reliable and disinterested people whose testimony was confirmed by others. Furthermore, they must have had considerable convictions to persist in their stories in the face of questioning by the FBI and the Commission Lawyers . . ." Then later, "If we take the cases at face value, people who saw someone who looked like Oswald, used Oswald's name, had Oswald's life and family . . . then how are they to be explained?"

May we suggest, Mr. Popkin, that Lee Harvey Oswald actually was seen by these witnesses and that the "aberrations" can be explained in terms of The Rumor! Oswald was simply seen at *other times* than the witnesses thought! Oswald's driving was

not a figment of *their* imagination . . . but of the control of *his* mind!

In Popkin's report he notes, as have so many, that "The police, the FBI, and the Secret Service were all amazed by his sang-froid and his continual protestations of innocence. . . . His brother Robert tells us that Lee assured him of his innocence and told him not to believe the 'so-called evidence.' "

Under deep R.H.I.C. control, Lee Oswald would have truly believed this and therefore had no trouble at all in maintaining that attitude. Indeed, his composure defies almost any other kind of explanation!

(It is of passing interest to note that Malcolm Muggeridge reported in *Esquire* magazine that he envisioned Oswald's behavior as that of a person in a "trance." A more apt description could hardly be found to describe the actions of a person under R.H.I.C.)

One final quote from Mr. Popkin, whose piece really is a must reading for anyone who wants to relish a distinguished critique of what has been written on this subject: He says in his concluding remarks, "The political or economic nature of the conspiracy must be purely speculative at this stage."

His use of the word "economic" causes us to speculate that perhaps he has heard whispers of The Rumor.

Almost all of the facts connected with the minutes that elapsed from the time of the shots to the time

that Oswald was apprehended for killing Tippit are clouded by confusion of *time*. Some of this is, of course, very natural under the frantic circumstances. Some of these distortions in recollection smack strongly of E.D.O.M.!

18.

Evaluating The Structure Of The Rumor

Before we move on to the execution of the crime, let us admit that it is simpler to accept the theory of the lone killer Oswald than even to consider The Rumor. It is far more comfortable to embrace the idea that Oswald's momentary madness alone caused the tragedy and that after it was over, we were left with just a bad memory. But we are haunted with the realization that the facts simply do not fit this concept.

We are left with Mr. One—a nervous, guilt-ridden man who fears the exposure of The Rumor.

Were We Controlled?

What supports this conjecture? Penn Jones, Jr., editor and publisher of the Texas newspaper, *The Midlothian Mirror,* has established in his excellent reports that at least thirteen persons who possessed possibly crucial information about the assassination have met with mysterious deaths.

Penn Jones has probably done more than anyone outside of the official investigative agencies to turn up new facts about the case. In his reports, Mr. Jones makes it quite clear that someone (Mr. One) is still tidying up loose ends.

One renowned member of the American press was aware of The Rumor and it troubled her. She was the late Dorothy Kilgallen, widely read gossip columnist and feature writer. The only reporter who had a private interview with Ruby, she must not be discounted simply because she dealt in the sensational. Dorothy numbered among her news sources, as this author has good reason to know, some of the most reliable authorities in high positions in the nation. She also had an army of press-agents and crackpots feeding her unfounded stories. If it so pleased her to fill a column with interesting readable fluff, she was not above doing exactly that. As the daughter of a famed veteran reporter, when the big story came along, Dorothy knew very well how to pinpoint the truth and cut away all superfluous nonsense. She was the woman dubbed by both

160

Damon Runyon and Ernest Hemingway as "the best reporter of our time."

The simple facts of the matter are these: Dorothy went to Dallas. She unearthed something so sensational that it would appear that she was thrown a healthy "bone" to keep her away from her typewriter for the moment. The "bone" was an accurate advance exclusive scoop of part of the testimony of the Warren Commission. It was an unprecedented favor granted to her; it was probably done to divert her from going in certain other directions in her investigation of the case. This, in the opinion of the author, was *not* done by the Government! In August of 1964, her exclusive bylined scoop made every reporter in America jealous. This, however, didn't really satisfy Dorothy. Underneath was a craving to print what she thought she had *really* uncovered.

As a willful spirited loner in her field, it was inevitable that when the mood eventually struck her, she would "leak" some of what was evidently intended never to reach print. She did exactly that.

On the night of December 21, 1964, she suddenly cast aside caution. In the middle of her column, after an innocuous item about Judy Garland, Dorothy switched into high-gear and wrote the following item. Her heading indicates she was absolutely sure her source was beyond question. It was—

161

Were We Controlled?

MEMO TO PRESIDENT JOHNSON: "Please check with the State Department . . . the leaders of our Armed Forces or our chief scientists, to discover what, if anything, we are doing to explore the ramifications of 'cloud-busting' which in its refined stages means *thought control* [our emphasis] . . . and could change the history of the world. We could catch up if someone in command gave the word before it was too late."

Later, in the fall of the next year (September 3, 1965), Dorothy Kilgallen wrote that she knew that if the whole story of the reason for Marina and Lee's behavior ever came out, it would split open the front pages of newspapers all over the world.

We believe it was The Rumor she was writing about when in that same column she warned, "The story isn't going to die as long as there's a real reporter alive—and there are a lot of them alive."

In a fascinating account in *Ramparts* magazine, reporter David Welsh offers the following postscript to Dorothy Kilgallen's role in the Oswald investigation. In connection with her death on November 8, 1965, Welsh reports:

A) A make-up man on her TV show quoted Kilgallen as saying shortly before her death that she would "crack this case."

162

B) A show-business intimate of Dorothy's claims that she told him in the last days of her life, "In five more days I'm going to bust this case wide open."

C) Mary Branum, an editor of *Screen Stars* magazine, said she received a phone call a few hours *before* Dorothy's body was discovered announcing that Kilgallen had been murdered!

D) Dr. James Luke, a New York City medical examiner, said there was no way of determining whether her death by "acute barbiturate and alcohol intoxication" was an accident, a suicide . . . or murder!

Was there in fact any connection between Dorothy Kilgallen's investigation of the Kennedy assassination and her death? We do not know . . . but she must be credited as the first to sound a serious warning in print to the general public about thought control. We do not believe that the unfinished story of Dorothy Kilgallen will be lost forever in yellowing old back issues.

* * *

We certainly agree with our many hard-working compatriots who have researched the point to an almost unbelievable degree that the witnesses who saw puffs of smoke from the knoll area were right.

There were indeed two rifles in play at the moment of the assassination. This would confirm the public testimony of the Governor of Texas and his wife whose observations, if accurate, would mean there had to be bullets from more than one source.

It was never, according to The Rumor, ever intended to be any other way. However, before we get to the second killer, consider the choice of Lee Oswald!

Mr. One had Lee Oswald "tested" very carefully to see if he would crumple when the crucial moment came or would calmly follow his control instructions.

These tests came in two stages.

The first test was designed to see if, under instructions, Lee would shoot at General Walker, a prominent public figure. He was given the instructions.

Lee took his rifle. He met an aide of Mr. One's. They drove to Walker's house. Lee calmly aimed the rifle and as soon as the other man saw that he *would* and *did* pull the trigger, he deliberately knocked the rifle off-target and led Oswald away to the car and they escaped. Nothing was to be gained by actually killing Walker. In fact, much could be lost.

The second test was to determine if Lee would calmly execute a man even further up the ladder of public prominence. This time, a few weeks later, he

was told that the former Vice President of the United States was to be his target.

Lee showed up at his rendezvous point and indicated he was under complete control and ready to act. This pleased Mr. One, who felt that Oswald was now ready.

This incident was later brought out in the Warren Commission report.

It must be noted that *only* The Rumor can explain why Oswald "thought" he was going out of the house to shoot Vice-President Nixon who was not even in the city at that time!

Mr. One and his aides evidently stayed close to the scene in Texas during the months of preparations for the fatal day. His penchant for determining for sure that a person's "control" was complete may have prompted him to order Tino De Angelis to New Orleans—at the time Lee Oswald was still there with Marina. De Angelis did admit to making a trip to New Orleans—seemingly a most remote place indeed to a man who had the troubles he did. This trip is noted in File 7036, Document 326, on page 28 of the Court Records.

In reconstructing the time-table of the crime, we see Lee Harvey Oswald, completely under R.H.I.C. control, calmly waiting at a window for the Kennedy car to pass by the metal traffic sign. This, he has been instructed, is the precise moment he is to fire

at the President. Another gunman is on the knoll near the overpass (a crack marksman elected by Mr. One, *unknown to Oswald,* to re-inforce his shooting).

His nerves are steady and his reflexes liquid-smooth for R.H.I.C. is completely in control, allowing no anxiety or nervousness to upset his aim. He is therefore better than the average marksman at this moment.

The car passes the sign. Both gunmen start fire at almost the same time. Then the almost robot-like Oswald, as per his instructions, leaves the rifle and unconcernedly slips downstairs and shortly thereafter out of the building. He is carrying his pistol on him. (This differs with printed theories that he went home and got it.) He has been controlled to forget his deadly rifle attack the minute he has fired three shots and to have no more memory of having fired them.

He is, however, controlled to expect that he may have trouble with a policeman that day. If it comes and it is serious—if he is accused of committing some major crime—he is to *shoot his way* out of the trouble! He is controlled to believe that unless he *does,* he will be *convicted of a very serious charge.* (He is told to take this action in the hope that he *will* shoot it out and be conveniently killed!)

He has been controlled to understand that some

great excitement will cause the Depository to be shut down—no work for the day. When that occurs, he is simply to quit work and kill time for the rest of the day . . . do anything that he enjoys . . . but of course . . . always with pistol handy in case of trouble.

The "trouble" comes when sharp-eyed Tippit does spot Oswald from the description . . . senses he may be the killer . . . and of course is himself killed while trying to pursue this point!

Oswald has been controlled many times to call for the legal help of John Abt if he ever needs aid. (This to throw a false clue toward the political left). He does. When Abt does not show up, he doesn't call any other lawyer . . . simply because he wasn't controlled for that eventuality.

The control only went so far, and therefore so did Oswald's robot-like demand for legal help.

He remained calm and of course sure of his innocence in connection with the President's slaying.

* * *

In the same city . . . Jack Ruby reacted in his typical extroverted and sensitive way to what was a traumatic experience for "his" Dallas . . . and underneath lay the "controlled" Ruby waiting for the signal of a phrase that he was pre-set to act upon, ac-

cording to The Rumor, when he heard it over the telephone.

That phone call came shortly before 10:00 a.m. on Sunday. Ruby was directed to slip immediately under "control" . . . to behave politely to everyone and go about his business in a normal manner and to *kill Lee Harvey Oswald!* He was already thoroughly primed as to his motives which were at the least sentimental and somewhat credible. This call was simply to say, in effect, *do it now.* When just a minute or two later Karen "Little Lynn", one of the performers in his Carousel Club, telephoned to ask a favor, she recalls that he replied, *"Well, I have to go downtown anyway".*

He did go downtown . . . and the familiar face of Jack Ruby was his passport to the right area . . . and he did indeed (completely under R.H.I.C. control) kill Lee Harvey Oswald!!

* * *

But there was a fateful crack in the R.H.I.C. curtain and through the inadequate application of R.H.I.C. to Jack Ruby's subconscious, he never quite forgot certain conversations that he overheard during his original indoctrination. He heard and retained (partly in his conscious) some fearful realization of an anti-Semitic, Nazi-like nature to the conspiring group who were trying to control him. Like a child

who is trying to talk about something beyond him, Ruby attempted in some of his public testimony to express some of this in words. He did very badly and in fact sometimes appeared rambling and disturbed—as indeed he was, but for a reason no one suspected.

There are a few facts in connection with Ruby's mutterings which we should evaluate for just a moment:

> For some reason, never explained, the assassination had its greatest effect (except for the U.S.) in, of all places, Argentina.
>
> On the night of the tragedy, Dr. Arthur U. Illia, President of Argentina, called an extraordinary first cabinet meeting. Just how extra special this was, is indicated by the fact that he did not call such a meeting again until June 10, 1965—and not again until his third and last one, which he called when he was ousted from office in July of 1966.
>
> Did he call that first cabinet meeting because he felt that something had happened that day that would benefit a group dedicated to ending his stay in power in Argentina and perhaps in some way gave this group the power—or the money—to eventually move him out of office?
>
> Were these people in this "group" the anti-

Semitic fascists that Jack Ruby feared? Consider this.

Directly after the military coup removed Illia from office in 1966, this appeared in *The New York Times* of July 3:

> "The arrest of six directors of a Jewish-led credit union cooperative heightened tension among Argentina's half million Jews today."

Later, in the article, it was noted that "nervousness has been rising among the Jewish community" since the military coup and "police squads arrested several shopkeepers in raids in a largely Jewish shopping arcade . . ."

To be sure, the impact of Kennedy's death caused many a foreign leader to give thought and express grief. But in Argentina, for some strange reason, a most extraordinary cabinet meeting was called by the man who was later ousted by a group whose Nazi-like actions were reported in *The New York Times* in the manner above.

We debated whether to include this slim clue to the possible credibility of Ruby's fears. We have included these facts because we think you should make the decision as to whether they in any way support what is known as The Rumor.

* * *

170

Evaluating The Structure Of The Rumor

Why, you may ask, if The Rumor is true did all the authorities fail to uncover it?

In this author's opinion, one can only marvel that so many investigators, at so many points, pecked away with such integrity at the *only visible threads* of evidence left by what surely was the cleverest, most technically sophisticated crime ever committed.

Without starting from the approach we have taken—without prior understanding of the tools and the motive—it is an almost unsolvable crime. If The Rumor has any basis in fact, then the patterns in this book will provide a handy guideline to future researchers who will seek out the truth.

Over and over again, those who investigated De Angelis and members of the Commission staff asked questions that *laid bare* parts of the structure of The Rumor. Instead of ridiculing their ignorance and lack of attention to their task, we often wondered as we reviewed the whole story what led them so often to the very edge of what may be the Big Truth.

The Rumor does offer:

1) A motive for the assassination.

2) An explanation for the aberration of time in so many of the witnesses' stories.

171

3) A key to the strangely mentally-confused Jack Ruby's actions and statements.

4) The only rational explanation for the Nixon incident.

5) The only answer to the question of why "crack marksman" Oswald could not hit the easy target provided by General Walker's stationary figure at a window.

6) The only credible explanation for the self-destructive course taken by De Angelis and Allied.

7) The unlocking of the riddle of Oswald and Marina.

But, you may say to yourself, who would believe that a man would be prepared *years before* to come back to this country to perform such an act?

Not all among us were sleeping. One at least considered the possibility. That man told the Commission:

> "But just the day before yesterday information came to me indicating that there is an espionage training school outside of Minsk . . . I don't know whether it is true . . . and that he [Oswald] was trained at that school to come back to this country to become what they call a

172

'sleeper' . . . that is a man who will remain dormant for three or four years and in case of international hostilities rise up and be used."

This extraordinary statement was made by J. Edgar Hoover!

Is it all true . . . or is it just a Rumor?

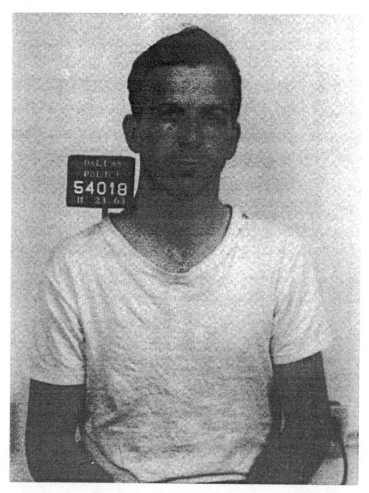

Oswald in the Dallas cell the day of the assassination (after being beaten-up by the police). "I am just a patsy," he said.

BIBLIOGRAPHY

Compiled by Kenn Thomas

Note: *Were We Controlled?* contains incomplete information about its sources. All of the information it offers is listed below with annotations where possible. Great credit goes to Lucinda Williams, Mark Scheu, Mary Zettwoch and Fran Schrage for tracking down these obscure sources.

"A Primer of Assassination Theories," *Esquire*. Vol. LXVI, No. 6, Whole No. 397, December 1966.

The same article was referenced by the psuedononymous William Torbitt in the Torbitt Document. See: *NASA, Nazis & JFK*, Adventures Unlimited Press, 1996.

Allhoff, Fred, "Lightning in the Night," *Liberty*, November 11, 1940.

Predicted the development of the atomic bomb.

Ammassian, Vahe, and Patton, Hary D., "Micro-electrode Analysis of Stimulation Effects on a Complex Synaptic Network," paper, 1961.

Barber, Theodore, *Journal of Psychology.*

Bekhterev, Vladimir, *Foundations of the Theory of the Functions of the Brain*, Russia, 1903, seven volumes.

Belli, Melvin with Carroll, Maurice, *Dallas Justice: The Real Story of Jack Ruby and His Trial.* New York: David McKay Company, 1964.

Written in a "spirit of constructive and sympathetic criticism of Dallas, Texas," Jack Ruby's defense attorney devotes two appendices to Ruby's psychological and neurological examinations, and one to Oswald's autopsy report. Ruby's examiners describe administering an electroencephalograph: "with the use of electrode jelly and bentinite paste, electrodes were placed in the standard frontal, central, occipital, anterior-temporal, mid-temporal, and post-temporal areas. The usual ear electrodes were used independently as reference points and for grounding during unipolar runs and jointly as a ground during bipolar runs." Nevertheless, Ruby seemed "relaxed and at ease" wired up this way. The testers conclude that abnormal readings taken from this process indicated a seizure disorder that accounted for "spells" about which Ruby complained. Belli's other published books include *Life and Law in Russia.*

Bickford, McDonald, Dodge and Svien, "Distant Evoked Responses to Single-Pulse Stimulation," paper, 1961.

Brandstadt, Wayne G., research on time sense, undated.

Branum, Mary, *Screen Stars.*

Chaffee, E. L. and Light, R. U., "A Method for the Remote Control of Electrical Stimulation of the Nervous System," paper, 1934.

Delgado, Jose, "The Evolution of the Human Brain," James Arthur Lecture, American Museum of Natural History, May 6, 1965.

"The limits of brain control do not seem to depend on electronic technology," Dr. Delgado assures the reader, "but on the biological properties of living neurons," after predicting the development of integrated circuits and thin film techniques leading to multi-channel micro-electronic radio-activated stimulators. His dispassionate descriptions of human and animal torture range from the horrifying ("screwing an ivory cone into the skull of an anesthetized dog, and the following day, when operative anesthesia had worn off, electrodes were inserted into the brain through the ivory piece") to the unintentionally Kafkaesque ("the prospect of

178

leaving wires inside the thinking brain could seem barbaric, uncomfortable, and dangerous, but actually the patients...have not been concerned about the idea of being wired or by the existence of leads in their heads...Some of the women proved the adaptability of the feminine spirit to all situations by designing pretty hats to conceal their electrical headgear.") Delgado refers briefly to the tentative nature of the therapeutic possibilties of this technology but concludes by emphasizing its importance in "patterning mental actvities."

Delgado, Jose, *Exerpta Medica International Congress* No. 87, Tokyo, 1965.

Delgado, Jose, "Personality, Education and Electrical Stimulation of the Brain."

Deutsch, J. Anthony, "Anti-cholinesterase and Dissolution of Memory," Berkeley Meeting of the American Association for the Advancement of Science, 1965.

Feron, James, article abour Earl Warren, *New York Times*, June 30, 1966.

"Global Grain Dealer--and More Besides," (Bunge Corporation Profile), *Business Week*, October 19, 1963.

In addition to the information used by

Lawrence, this article discusses the almost informal structure of Bunge: "In a field where verbal aggrements are the rule, even in big sales, Bunge traders are able to make deals around the world through members of their own organization...Bunge operations in various countries are mostly organized as independent, largely autonomous companies, though financially controlled by the same shareholders." Bunge headquarters is in Argentina, home also of many exiled Nazis, although some financial control also is exerted from Belgium. "A loose affiliation of millionaires," as the Paul Simon song goes. A grain deal with Soviet trade officials provided the occasion of this profile, during a brief Cold War thaw that promised new Russian market possibilities for US corporations. Another article in the same issue of *Business Week* called it "a chink in the wall, but no more."

Gregory, Richard L., article on perception, Department of Psychology, Cambridge University, undated.

Gregory wrote a book called *Odd Perceptions*, (New York: Methuen) published in 1986.

Huie, William Bradford, "ATTENTION PRESIDENT! Read the story MURDER IN TEXAS!", untitled magazine, August 1961.

Interestingly, Huie wrote a book, *Three Lives for Mississippi* (New York: New American Library, 1968), with an introduction by Martin Luther King, Jr. and another about King's assassination "with" accused assassin James Earl Ray, entitled *He Slew the Dreamer* (New York: Delacorte Press, 1970). Huie also wrote *The Execution of Private Slovik* (New York: Delacorte Press, 1970.)

Jasper, Herbert J., *Implications for the Neurological Sciences.*

Jasper lectures internationally on electro-encephalography, neuronal hyperexcitability, brain hemispheres and epilepsy.

Jones, Penn, *Midlothian Mirror*, 1960s.

Jones is an early and much respected critic of the Warren Commission. His writings were collected in *Forgive My Grief* (Midlothian, Texas: Midlothian Mirror, 1966).

Kilgallen, Dorothy, syndicated newspaper column, December 21, 1964.

Kilgallen's published books include: *Murder One* (New York: Random House, 1967), on crime case studies, including that of Dr. Samuel Shepperd; and a travel memoir, *Girl Around The*

World (Philadelphia: David McKay Company, 1936.)

Krech, David K., "Mind Control Coming, Scientist Warns," *New York Times.*

Miller, Neal E., "Learning and Performance Motivated by Direct Stimulation of the Brain."

In the 1930s Miller researched and wrote about frustration and aggression; in 1947 he did psychological research on training pilots; he specialized in social learning in the 1950s; in the 1980s he contributed to biofeedback research.

Miller, Norman C., *The Great Salad Oil Swindle*, New York: Coward Mcann, Inc., 1965.

Biographical information on Tony De Angelis and great historical detail about the short-selling spree inspired by his salad oil inventory machinations. "De Angelis insisted to the end that he had been sabotaged by mysterious forces," notes Miller, although he does not explore the mind control angle. Similarly, the Kennedy assassination plays only a peripheral role in the financial scandal: "The nation's panic at the tragedy was immediately reflected in the stock market and exchange officials were swept into a second terrible crisis. In twenty-seven minutes, the Dow Jones industrial average plummeted twenty-four points as

more than 2.6 million shares were traded in a sell-off that had never been equaled in intensity. The panic was so great that the exchange board of governors closed the market at 2:07 P.M., eighty-three minutes before the normal closing time." Only Garnac Grain Company president Fred Hediger voices concern over the coincidence of disasters, in a passage quoted by Lawrence: "I thought, this must be a plot by the Russians or the underworld--too many crazy things are happening at once."

Miller blames the salad oil fiasco on the decidedly non-mysterious lust for profit that allowed an obvious swindler like De Angelis to climb the corporate hierarchy. According to Miller, the mistake was to allow De Angeles' profit making ability to be the only measure of his value to the corporation. The view ignores the possibility that the stock manipulations were purposeful, to create "black profit" funding for other secret activities of transnational corporate control groups. Miller makes this note about Bunge Corporation, however: "This enormous enterprise['s]...globe-girdling activities have earned it the nickname 'The Octopus.'"

New York Times, July 3, 1966

"The arrest of six directors of a Jewish-led credit union cooperative heightened tension among Argentina's half million Jews today."

Osmundsen, John A., "Matador with a Radio Stops Wired Bull," *New York Times*, May 17, 1965.

Popkin, Richard, *New York Review of Books*, undated.

RCA Communications, "Modern Global Communications Meet the Challenge."

Ostensibly concerns Bunge Corporation's communications network.

Smith, William ER., *Assassination By Consensus*, L'Avant Garde, 1966, 240 pp.

Although full details of Smith's "psychic displacement" theory of the Kennedy assassination remain in his apparently unrecoverable previous publications (*The GOM Pattern; The Green Mirror, Knight of the Black Veil; The Goldwater Papers* et. al), this book offers a glimpse of an early mind-control rant on the subject. Smith describes psychic displacement as "a system utilized for the purpose of manipulating mass behavior," a possibility that Jose Delgado regarded as very unlikely. Smith notes, however, that "completely separate movements relating to psychic displacement were initiated which employed a general psychological catalyst but which produced a reaction that was specific on an area basis, depending on regional and sectional prejudices."

The book opens with discussion of "Operation Good Feeling," a period of rapprochement between the superpowers that coincides with the timing of the Soviet wheat deals with Bunge Corporation.

Smith descibes a control system using word coincidences: "Oswald had stated in his letter to Albert Schweitzer Institute that he wanted to study the German language. The first hotel in which he stayed in Moscow was the Hotel Berlin. The girl that he fell in love with was named Ella German." Even paper colors take on extra significance: "*The Green Mirror* was printed on light brown paper at the suggestion of the printer. It was alleged that on the day before the assassination Lee Oswald removed the rifle that was supposed to have been contained in the blanket and wrapped it in brown paper."

The author also alludes to changes made in his military identification card connecting him to Robert F. Williams, an African American defector to Cuba, and correspondence with Barry Goldwater on the Bay of Pigs in early 1963. "Now much psychic displacement involves creating parallel identities with those contained in an incident that it is desired to suppress information about so that the themes contained in the one become associated with the other."

Smith also uses C. G. Jung as a basis for speculating that Oswald and his wife Marina were manipulated into bi-sexual activity among their

White Russian friends, including George DeMorenschildt and Michael and Ruth Paine. He asserts, though, that "Lee Oswald developed an understanding of the system of psychic displacement and sought to exploit it to his advantage. His purpose was to raise himself from poverty, ignorance, and insignificance; or, as the expression went in Texas, he wanted to 'raise himself by his own bootstraps.'"

Assassination By Consensus concludes that Kennedy's assassination resulted from "discontent over water pollution, food poisoning, government and private snooping and a host of secondary illnesses created by these conditions...These conditions, when associated with the manipulative process known as psychic displacement, from a mechanical view, induced the polarization of individuals and groups into negative and positive alignments with a fusion taking place at the negative position producing a phenomenon that we refer to as 'The Green Revolution.'"

True Magazine, Frederick Hediger quote, undated.

United States Panel on Educational Research and Development (corporate author), *Innovation and Experiment in Education: A Progress Report of the Panel on Educational Research and Development to the U. S. Commissioner of Education, the Director of the National Science Foundation, and the Special Assistant to the President for Science and Technology,*

186

Washington: U.S. Government Printing Office, 1964.

Vasiliev, L. L., "Critical Evaluation of the Hypnogenic Method of the Results Obtained by its Application (Improved Version of the Hypnogenic Method from Experiments in Mental Suggestion)," University of Leningrad, 1934.

"Was The Kennedy Assassination Engineered?" Advertisement, *New York Times*, August 1964.

Warren Commission testimony.

Warren David M, untitled paper, Chicago, IL: unpublished, 1960s.

Welsh, David, *Ramparts*.

World Meteorological Organization, "The Effect of Electricity on the Human Body."

INDEX

THE ADVENTURES
UNLIMITED
CATALOG

NEW BOOKS

RETURN OF THE SERPENTS OF WISDOM
by Mark Amaru Pinkham

According to ancient records, the patriarchs and founders of the early civilizations in Egypt, India, China, Peru, Mesopotamia, Britain, and the Americas were colonized by the Serpents of Wisdom—spiritual masters associated with the serpent—who arrived in these lands after abandoning their beloved homelands and crossing great seas. While bearing names denoting snake or dragon (such as Naga, Lung, Djedhi, Amaru, Quetzalcoatl, Adder, etc.), these Serpents of Wisdom oversaw the construction of magnificent civilizations within which they and their descendants served as the priest kings and as the enlightened heads of mystery school traditions. The Return of the Serpents of Wisdom recounts the history of these "Serpents"—where they came from, why they came, the secret wisdom they disseminated, and why they are returning now.
"An amazing bit of work. I highly recommend it to those who seek information on the worldwide mystery schools and master builders that once existed in the past and are flourishing again.
—David Hatcher Childress, author of the Lost Cities Series.
332 PAGES. 6x9 PAPERBACK. ILLUSTRATED. REFERENCES. $16.95. CODE: EDE

THE LOST TEACHINGS OF ATLANTIS
And the Children of the Law of One
by the Children of the Law of One

Are the Lost Teachings of Atlantis kept in a secret monastery in Tibet? According to this fascinating book, in a remote mountain valley in Tibet are the ruins of a mysterious monastery built before the Great Pyramid. It was built by a strange people thought to be gods. Their archives contained amazing revelations from our ancient ancestors — Angelic beings who became human to light our way home. They were the first spiritual masters, and the forefathers of countless religions. This book is their history, prophecy and knowledge with chapters on Energy Techniques, Meditations, Science-Magic, Universal Law, the Nature of Life & God and the Secrets of Inner Peace, Freedom & Enlightenment.
302 PAGES. 6x9 PAPERBACK. $18.95. ILLUSTRATED. CODE: LTA

MIND CONTROL, WORLD CONTROL
by Jim Keith

Mind control is little-known and a highly controversial topic today. Veteran author and investigator Jim Keith uncovers a surprising amount of information on the technology, experimentation and implementation of mind control technology. Various chapters in this shocking book are on early C.I.A. experiments such as Project Artichoke and Project R.H.I.C.-EDOM, the methodology and technology of implants, mind control assassins and Couriers, various famous "Mind Control" victims such as Sirhan Sirhan and Candy Jones. Also featured in this book are chapters on how Mind Control technology may be linked to some UFO activity and "UFO abductions." Jim Keith is the former editor of *Dharma Combat* and the author of such books as *THE GEMSTONE FILE, CASEBOOK ON ALTERNATIVE 3, SECRET & SUPPRESSED.*
256 PAGES. 6x9 PAPERBACK. PHOTO SECTION. NOTES. $14.95. CODE: MCWC

THE MYSTERY OF EASTER ISLAND
by Katherine Routledge

The reprint of Katherine Routledge's classic archaeology book on Easter Island was first published in London in 1919. Portions of the book later appeared in *National Geographic* (1924). Heavily illustrated with a wealth of old photos, this book is a treasure of information on that most mysterious of islands: Rapa Nui or Easter Island. The book details Katherine Routledge's journey by yacht from England to South America, around Patagonia to Chile and on to Easter Island. Routledge explores the amazing island and produced one of the first-ever accounts of the life, history and legends of this strange and remote place. Routledge discusses the statues, pyramid-platforms, Rongo Rongo script, the Bird Cult, the war between the Short Ears and the Long Ears, exploring the secret caves, ancient roads on the island, and more. This rare early book on Easter Island serves as a sourcebook on the early discoveries and theories on the island. Original copies, when found, sell for hundreds of dollars so get this valuable reprint now at an affordable price.
432 PAGES. 6x9 PAPERBACK. ILLUSTRATED. $16.95. CODE: MEI

MIND CONTROL, OSWALD & JFK:
Were We Controlled?
Introduction by Kenn Thomas

Steamshovel Press editor Kenn Thomas examines the little-known book *Were We Controlled?* which was first published in 1969 by an anonymous author. The book maintained that Lee Harvey Oswald was a special agent who was also a mind control subject who had received an implant in 1960 at a Russian hospital. Thomas examines the evidence for implant technology and how this could have played a role in the Kennedy Assassination. Thomas also looks at the mind control aspects concerning the RFK assassination and details the history of implant technology. A growing number of people are interested in C.I.A. experiments and their "Silent Weapons for Quiet Wars." Kenn Thomas is the editor of *Steamshovel Press*, an academic politics and conspiracy magazine and the editor of *NASA, NAZIS & JFK, THE OCTOPUS* and *POPULAR ALIENATION.*
256 PAGES. 6x9 PAPERBACK. PHOTO SECTION. NOTES. $16.00. CODE: MCOJ

CONSPIRACY & HISTORY

NASA, NAZIS & JFK:
The Torbitt Document & the JFK Assassination
Introduction by Kenn Thomas
This book emphasizes the link between Operation Paper Clip Nazi scientists working for NASA, the assassination of JFK, and the secret Nevada air base Area 51. The Torbitt Document also talks about the roles in the assassination played by Division Five of the FBI, Defense Industrial Security Command (DISC), the Las Vegas mob, and the shadow corporate entities Permindex and Centro-Mondiale Commerciale. The Torbitt Document claims that the same people planned the 1962 failed assassination of Charles de Gaul, who ultimately pulled out of NATO because he traced the "Assassination Cabal" to Permindex in Switzerland and to NATO headquarters in Brussels. The Torbitt Document paints a dark picture of NASA, the Military Industrial Complex, and the connections to Mercury, Nevada which headquarters the "secret space program."
258 PAGES. 6X9 PAPERBACK. ILLUSTRATED. $16.00. CODE: NNJ

PROJECT SEEK
Onassis, Kennedy and the Gemstone Thesis
Gerald A. Carroll
This book reprints the famous Gemstone File, a document circulated in 1974 concerning the Mafia, Onassis and the Kennedy Assassination. With the passing of Jackie Onassis-Kennedy, this information on the Mafia & the CIA, the formely "Hughes" controlled Defense Industry, and the violent string of assassinations can at last be told. Also includes new information on the Nugan Hand Bank, the BCCI scandal, "the Octopus," and the Wilcher Transcripts.
388 PAGES, 6X9 PAPERBACK. ILLUSTRATED. $16.95. CODE: PJS

IT'S A CONSPIRACY!
The Shocking Truth About America's Favorite Conspiracy Theories
by The National Insecurity Council
A great rundown of over 60 conspiracy theories. Included are chapters on World War II conspiracies, including the SS and the CIA, Reinhard Gellen, Operation Paperclip, how the Allies created a false Cold War and arms race against the Soviets, Bush's early CIA years, and more. Discussed in detail are the assasinations of JFK, RFK, MLK, Malcolm X, Oswald and others. Nazi-CIA-banking connections, banking conspiracies, media cover-ups, Saddam Hussein and the Gulf War, the story behind the Red Menace, and more shocking information.
252 PAGES, 6X9 TRADEPAPER. $9.95. CODE: IAC

BLACK HELICOPTERS OVER AMERICA
Strikeforce for the New World Order
by Jim Keith
Veteran author Keith starts with an overview of "black helicopter" incidents starting in 1971. Many of these incidents are curiously related to cattle mutilations in the same area at the same time. Delves into such topical subjects as black choppers and UFOs; the building of network of concentration camps by the U.S. government; U.N. troop movements reported across America; FEMA as the cover for a police-state; more.
155 PAGES, 6X9 PAPERBACK. ILLUSTRATED. $12.95. CODE: BHOA

PARANOID WOMEN COLLECT THEIR THOUGHTS
edited by Joan D'Arc
The editor of Paranoia magazine, Joan D'Arc has collected the fears of the present and future from a cross section of women with direct experience. Regina Cullen writes on her experience in microwave harrassment from the government. Leah Halley and her experiences with "Aliens," Tales of Mind Control, Virgin Mary Apparitions, E.T. Encounters or Mind Controll Hoax? by Mary Seal, Earth vs the Flying Saucers by Joan D'Arc, Why Was Patty Hearst Kidnapped by Mae Brussel, Microchip Injection, more. Plenty of UFO, mindcontrol and other conspiracy rants.
152 PAGES, 9X11 PAPERBACK. ILLUSTRATED. $10.95. CODE: PWO

DEFRAUDING AMERICA
Dirty Secrets of the CIA and other Government Operations
Rodney Stich
With solid evidence Stich details the underhanded operations of the Nugan Hand Bank, the BCCI, CIA and DEA drug trafficking, the October Surprise Cover-up, Inslaw and the Promis Software for Big Brother, Israel and the Mossad, the Clinton "gang" and more. Lengthy portions of the book go into details of Gunther Russbacher's Blackbird SR71 Spyplane flight with George Bush to Paris, the Wilshire Documents, more.
654 PAGES. 6X9 TRADEPAPER. ILLUSTRATED WITH INDEX. $25.00. CODE: DFA

DISAVOW
A CIA Saga of Betrayal
by Rodney Stich and T. Conan Russell
This documented book reveals the innermost secrets of a large CIA operation headquartered in Hawaii, how deep-cover CIA functions are funded, how these covert operations are sometimes exposed, how plausible denial works and how CIA officials avoid responsibility for their acts while shifting the blame to innocent parties. For all those interested in recent banking controversies such as the BCCI Bank, money laundering and covert funding.
392 PAGES, 6X9 PAPERBACK. PHOTO SECTION. INDEX. $22.00. CODE: DIS

CONSPIRACY & HISTORY

THE HISTORY OF THE KNIGHTS TEMPLAR
The Temple Church and the Temple
by Charles G. Addison. Introduction by David Hatcher Childress

Chapters on the origin of the Templars, their popularity in Europe and their rivalry with the Knights of St. John, later to be known as the Knights of Malta. Detailed information on the activities of the Templars in the Holy Land, and the 1312 A.D. suppression of the Templars in France and other countries, culminating in the execution of Jacques de Molay. Also information on the continuation of the Knights Templars in England and Scotland and the formation of the society of Knights Templar in London and the rebuilding of the Temple in 1816. Plus a lengthy introduction about the lost Templar fleet and its connections to the ancient North American sea routes.
395 PAGES. 6x9 PAPERBACK. ILLUSTRATED. $16.95. CODE: HKT

POPULAR ALIENATION
Edited by Kenn Thomas

This oversized book is a compilation of the conspiracy magazine *Steamshovel Press*. It includes everything from the role of Nixon and Bush in the JFK assasination to Lee Harvey Oswald weirdness, The Gemstone File, to stuff about Wilhelm Reich, Timothy Leary, Mae Brussell, Philip K. Dick and the Illuminati, Shroud of Turin, Nazi UFOs and the CIA, JFK's LSD trips, Carlos Castenada, Project Bluebook, Mothmen, Danny Casolaro and The Octopus, more—and then some!
288 PAGES. 9x12 PAPERBACK. PHOTO SECTION. $19.95. CODE: PAL

CONSPIRATORS' HIERARCHY:
The Story of the Committee of 300
Dr. John Coleman

This documented book is about a powerful group of International Bankers, Industrialists and Oil Magnates trying to control the world. Chapters include information on past and present institutions involved with the so-called Committee of 300 as well as Legal Associations and banks that were or are now under their control. Includes an index and a table of the Committe of 300 in the back.
288 PAGES, 6x9 TRADEPAPER, ILLUSTRATED, WITH INDEX. $16.95. CODE: CHR

INFLUENCING MINDS
A Reader In Quotations
by Leonard Roy Frank

Influencing Minds assembles concentrated granules of commentary on that most delicate subject; the shaping of the human mind. These bite-sized quotes from famous authors, scientists and politicians are grouped together in sections such as Ideology, Higher Education, Persuasion, Journalists and the Media, Deception, Propaganda, Brainwashing, Psychiatry, Dreams, Transformation and more. "To transform the world and society, we must first and foremost transform ourselves."—Ho Chi Minh.
245 PAGES, 6x9 PAPERBACK. WITH AUTHOR INDEX. $12.95. CODE: INM

PSYCHIC DICTATORSHIP IN THE USA
by Alex Constantine

Bombing minds is the warfare of the new millennium. Funded under the euphemism of "Non-Lethal Technology," the Pentagon has developed the ability to transmit voices, and inflict pain, madness, even death, at the push of a button. This book investigates the use of cults by intelligence operatives for arms sales, mind control and even child abuse to create assassins with multiple personality syndrome. Also: Nutrasweet & "mind control" experiments; False Memory; mind control and UFO encounters; the technology involved; more.
221 PAGES. 6x9 PAPERBACK. ILLUSTRATED. $12.95 CODE:PSU

THE HISTORY OF AMERICAN CONSTITUTIONAL OR COMMON LAW
by Pond, Fisher, Knutson & the North American Freedom Council

We can see the deterioration of the democratic process in America and the misuse of power over many by a few. This no-nonsense history is also a guide to show how "we the people" can restore ourselves as Masters of Congress and our Country where we instruct our government employees what to do instead of taking orders from them. Includes 16 sample court arguments and briefs including Rights of a Freeman, Common Law vs Civil Law Rights, Corpus Delicti, Federal Citizen or Sovereign Citizen?, more.
142 PAGES, 9x11 PAPERBACK. ILLUSTRATED. INDEX. $11.95. CODE: HCL

PAN AM 103
The Lockerbie Cover-Up
by William C. Chasey

According to William Chasey, there is a cover-up occuring over the Lockerbie disaster that makes "Watergate, Irangate and Whitewater pale by comparison." Casey claims that the United States and Great Britain have conspired to keep the real perpetrators from being exposed while they falsely accuse Libya. Chasey discloses information that was previously covered-up and names the real parties responsible. Demonstrates a credible case that Pan Am 103 has a deeper story to tell.
372 PAGES, 6x9 TRADEPAPER. ILLUSTRATED. INDEX. $17.95. CODE: PA3

SECRET AND SUPPRESSED
Banned Ideas & Hidden History
edited by Jim Keith

A ride into the world of conspiracies suppress history. Chapters on Jonestown in Guyana as a CIA mind control effort, the "invitation to war" to Saddam Hussein, silent weapons for quiet wars, Danny Casolaro's "Octopus" manuscript. Also: Why Waco?, AIDS: An Act of the Pentagon, Secrets From the Vatican Library, Brain Implants, Exposing Nazi International. more.
309 PAGES. 6x9 PAPERBACK. ILLUSTRATED. $12.95. CODE: SSUP

CONSPIRACY & HISTORY

ARKTOS:
The Myth of the Pole in Science, Symbolism, and Nazi Survival
by Joscelyn Godwin
A scholarly treatment of catatastrophes, ancient myths and the Nazi Occult beliefs. Explored are the many tales of an ancient race said to have lived in the Arctic regions, such as Thule and Hyperborea. Progressing onward, the book looks at modern polar legends; including the survival of Hitler, German bases in Antarctica, UFOs, the hollow earth, and the hidden kingdoms of Agartha and Shambala.
220 PAGES. 6X9 TRADEPAPER. ILLUSTRATED. $16.95. CODE: ARK

EMERALD CUP—ARK OF GOLD
The Quest of SS Lt. Otto Rahn of the Third Reich
by Col. Howard Buechner
This book chronicles the voyages of Jesus and Joseph of Arimathea to England, and of the Emerald Cup—the Holy Grail of legend. Buechner traces the legend of the Holy Grail, explaining exactly what it is. Also included: King Arthur, King Solomon's treasure, Rennes-le-Chateau, and the strange quest of a German SS officer to a remote castle in the Pyrenees Mountains of France.
253 PAGES. 7X9 TRADEPAPER. ILLUSTRATED. $16.95 CODE: EMC

THE CUP OF DESTINY
The Quest For the Grail
by Trevor Ravenscroft
Ravenscroft seeks to answer the growing interest in the spiritual significance of the quest sagas of the Middle Ages. In taking us beyond the enchanting drama and symbolism into the very heart of the legend of the Holy Grail, he unveils a unique path of initiation into the deepest mysteries of Christianity and makes obvious the parallels to other faiths, including Buddhism, Zoroastrianism and Manichaeism. Ravenscroft takes us step by step to an understanding of Parzival and his quest for the Holy Grail.
194 PAGES. 6X9 PAPERBACK. $11.00. CODE: CUP

THE SPEAR OF DESTINY
The Occult Power Behind the Spear Which Pierced the Side of Christ
by Trevor Ravenscroft
Ravenscroft's cult classic records the legend of the Spear of Destiny and its continuing fulfillment in the decline of the Roman Empire, the Dark Ages, and the 20th century. It tells the story of the chain of men who possessed the Spear, from Herod the Great to Adolf Hitler, and how they sought to change the face of history by wielding its occult powers for good or evil. Discusses Hitler's past lives, Rudolf Steiner vs. the Nazis, Tibetan Black Magicians of "Schamballah and Agarti," more.
362 PAGES. 6X9 PAPERBACK. ILLUSTRATED. $12.95. CODE: SOD

SECRETS OF THE HOLY LANCE
by Col. Buechner & Capt. Wilhelm Bernhart
One of the most incredible books on lost treasure, secret societies, ancient relics and WWII ever written. Taking up where *The Spear of Destiny* by Trevor Ravenscroft leaves off, this book relates that the Holy Lance was secretly taken to a base in Antarctica, while a replica was returned to the Vienna Museum. A book packed with strange information on Nazi bases in Antarctica, Himmler and the SS, U-boats carrying important Nazis to South America and Hitler's secret treasure.
223 PAGES. 6X9 TRADEPAPER. ILLUSTRATED. $16.95. CODE: SHL

CULT RAPTURE
by Adam Parfrey
Village Voice journalist Adam Parfrey's distinctive journalistic approach to such far-out topics as UNARIUS and the UFOs; Russian Mail Order Brides; Sai Baba; Shock Treatment; Project Monarch and Mind Control; Bo Gritz, Linda Thompson and WACO; the "cult of SWAT cops in action;" the bombing of the federal building in Oklahoma City and what it means to America; "How To Frame A Patriot;" those strange weeping child paintings; more weirdness and "cult conspiracy" in Parfrey's unique leftist style.
371 PAGES. 6X9 PAPERBACK. ILLUSTRATED. FOOTNOTES & BIBLIOGRAPHY. $14.95. CODE: CULT

CONSPIRACIES, COVER-UPS & CRIMES
From Dallas To Waco
by Jonathan Vankin
Journalist Jonathan Vankin on Oswald as a Nazi Breeding Experiment; Votescam, Get LaRouche!; UFOs in the Garden of Eden; The Invisible Government; Mae Brussel vs the CIA and NAZI partners; the Christic Institute's lawsuit against "The Secret Team;" Coup D'Etat in the U.S.A.; Kinder, Gentler Death Squads; This is Your Government on Drugs; CIA: The Department of Conspiracy; Shots From the Bushy Knoll; From Mysteries to Masonry; Conspiracy Nation; and other shady subjects.
384 PAGES. 6X9 PAPERBACK. ILLUSTRATED. $16.95. CODE: CCC

THE IMMACULATE DECEPTION
The Bush Crime Family Exposed
by Russell S. Bowen
The book explores these serious questions_George Bush's whereabouts (1)when the Bay of Pigs fiasco was planned and executed?; (2)when John F. Kennedy, Martin Luther King and Robert F. Kennedy were assassinated?; (3)when Ronald Reagan was nearly assassinated in Washington by a known Bush family associate. Plus the early CIA years, more.
210 PAGES. 5X8 TRADEPAPER. $12.95. CODE: TID

24 HOUR CREDIT CARD ORDERS—CALL: 815-253-6390 FAX: 815-253-6300
EMAIL: AUP@AZSTARNET.COM HTTP://WWW.AZSTARNET.COM/~AUP

ANTI-GRAVITY

UFOS AND ANTI-GRAVITY
Piece For A Jig-Saw
by Leonard G. Cramp
Long out of print, Leonard G. Cramp's 1966 classic book on flying saucer propulsion and suppressed technology is available again. Cramp wrote *Space, Gravity and the Flying Saucer* in 1954 and was Vice-President of the British UFO Research Association (BUFORA). *UFOS & Anti-Gravity: Piece For A Jig-Saw* is a highly technical look at the UFO phenomena by a trained scientist. Cramp first introduces the idea of 'anti-gravity' and introduces us to the various theories of gravitation. He then examines the technology necessary to build a flying saucer and examines in great detail the technical aspects of such a craft. Cramp's book is a wealth of material and diagrams on flying saucers, anti-gravity, suppressed technology, G-fields and UFOs. Chapters include Crossroads of Aerodymanics, Aerodynamic Saucers, Limitations of Rocketry, Gravitation and the Ether, Gravitational Spaceships, G. Field Lift Effects, The Bi-Field Theory, VTOL and Hovercraft, Analysis of UFO photos, more. "I feel the Air Force has not been giving out all available information on these unidentified flying objects. You cannot disregard so many unimpeachable sources." — John McCormack, Speaker of the U.S. House of Representatives.
388 PAGES. 6x9 PAPERBACK. HEAVILY ILLUSTRATED. $16.95. CODE: UAG

THE FREE-ENERGY DEVICE HANDBOOK
A Compilation of Patents and Reports
by David Hatcher Childress
A large-format compilation of various patents, papers, descriptions and diagrams concerning free-energy devices and systems. *The Free-Energy Device Handbook* is a visual tool for experimenters and researchers into magnetic motors and other "over-unity" devices. With chapters on the Adams Motor, the Hans Coler Generator, cold fusion, superconductors, "N" machines, space-energy generators, Nikola Tesla, T. Townsend Brown, and the latest in free-energy devices. Packed with photos, technical diagrams, patents and fascinating information, this book belongs on every science shelf. With energy and profit being a major political reason for fighting various wars, free-energy devices, if ever allowed to be mass-distributed to consumers, could change the world! Get your copy now before the Department of Energy bans this book!
292 PAGES. 8X10 TRADEPAPER. ILLUSTRATED. BIBLIOGRAPHY. $16.95. CODE: FEH

UNDERGROUND BASES & TUNNELS
What is the Government Trying to Hide?
by Richard Sauder, Ph.D.
Working from government documents and corporate records, Sauder has compiled an impressive book that digs below the surface of the military's super-secret underground! Go behind the scenes into little-known corners of the public record and discover how corporate America has worked hand-in-glove with the Pentagon for decades, dreaming about, planning, and actually constructing, secret underground bases. This book includes chapters on the locations of the bases, the tunneling technology, various military designs for underground bases, nuclear testing & underground bases, abductions, needles & implants; Is the Military Involvement in "alien" cattle mutilations?, more. 50 page photo & map insert.
201 PAGES. 6X9 PAPERBACK. WELL ILLUSTRATED. $15.95. CODE: UGB

MAN-MADE UFOS 1944—1994
Fifty Years of Suppression
by Renato Vesco & David Hatcher Childress
A comprehensive look at the early "flying saucer technology" of Nazi Germany and the genesis of early man-made UFOs. This book takes us from the early days of captured German scientists, to escaped battalions of Germans, secret communities in South America and Antarctica to todays state-of-the-art "Dreamland" flying machines. Heavily illustrated, this astonishing book blows the lid off the "government UFO conspiracy" and explains with technical diagrams the technology involved. Examined in detail are secret underground airfields and factories; German secret weapons; "suction" aircraft; the origin of NASA; gyroscopic stabilizers and engines; the secret Marconi aircraft factory in South America; and more. Not to be missed by students of technology suppression, secret societies, anti-gravity, free energy conspiracy and World War II! Introduction by W.A. Harbinson, author of the Dell novels *GENESIS* and *REVELATION.*
318 PAGES. 6X9 TRADEPAPER. ILLUSTRATED. INDEX & FOOTNOTES. $18.95. CODE: MMU

EXTRATERRESTRIAL ARCHAEOLOGY
by David Hatcher Childress
With 100s of photos and illustrations, *Extraterrestrial Archaeology* takes the reader to the strange and fascinating worlds of Mars, the Moon, Mercury, Venus, Saturn and other planets for a look at the alien structures that appear there. Using official NASA and Soviet photos, as well as other photos taken via telescope, this book includes many blow-ups of NASA photos and detailed diagrams of structures— particularly on the Moon.

•NASA PHOTOS OF PYRAMIDS AND DOMED CITIES ON THE MOON.
•PYRAMIDS AND GIANT STATUES ON MARS.
•ROBOT MINING VEHICLES THAT MOVE ABOUT THE MOON PROCESSING VALUABLE METALS.
•NASA & RUSSIAN PHOTOS OF SPACE-BASES ON MARS AND ITS MOONS.
•A BRITISH SCIENTIST WHO DISCOVERED A TUNNEL ON THE MOON, AND BOTTOMLESS CRATERS.
•EARLY CLAIMS OF TRIPS TO THE MOON AND MARS.
•STRUCTURAL ANOMALIES ON VENUS, SATURN, JUPITER, MERCURY,URANUS & NEPTUNE.
308 PAGES. 8X11 PAPERBACK. BIBLIOGRAPHY. APPENDIX. $18.95. CODE: ETA

ANTI-GRAVITY

THE ANTI-GRAVITY HANDBOOK

Edited by David Hatcher Childress, With Arthur C. Clarke, Nikola Tesla, T.B. Paulicki, Bruce Cathie, Leonard G. Cramp and Albert Einstein

The new expanded compilation of material on Anti-Gravity, Free Energy, Flying Saucer Propulsion, UFOs, Suppressed Technology, NASA Cover-ups and more. Highly illustrated with patents, technical illustrationsand photos. This revised and expanded edition has more material, including photos of Area 51, Nevada, the government's secret testing facility. This classic on weird science is back in a 90s format!

• How to build a flying saucer.
•Arthur C. Clarke on Anti-Gravity.
• Crystals and their role in levitation.
• Secret government research and development.
• Nikola Tesla on how anti-gravity airships could
 draw power from the atmosphere.
• Bruce Cathie's Anti-Gravity Equation.
• NASA, the Moon and Anti-Gravity.

230 PAGES, 7x10 TRADEPAPER, BIBLIOGRAPHY/INDEX/APPENDIX. HIGHLY ILLUSTRATED WITH 100'S OF PATENTS ILLUSTRATIONS AND PHOTOS. $14.95. CODE: AGH

ANTI-GRAVITY & THE WORLD GRID

edited by David Hatcher Childress

Is the earth surrounded by an intricate network of electromagnetic grid network offering free energy? This compilation of material on ley lines and world power points contains chapters on the geography, mathematics, and light harmonics of the earth grid. Discover how the grid made the Philadelphia Experiment possible. Explore the Coral Castle and many other mysteries; Including acoustic levitation, Tesla Shields and scalar wave weaponry. Browse through the section on anti-gravity patents, and research resources.

274 PAGES, 150 RARE PHOTOGRAPHS, DIAGRAMS AND DRAWINGS, 7x10 PAPERBACK, $14.95. CODE: AGW

ANTI-GRAVITY & THE UNIFIED FIELD

Edited by David Hatcher Childress

Is Einstein's Unified Field Theory the answer to all of our energy problems? Explored in this compilation of material is how gravity, electricity and magnetism manifest from a unified field around us. Why artificial gravity is possible; secrets of UFO propulsion; free energy; Nikola Tesla and anti-gravity airships of the 20's and 30's; flying saucers as superconducting whirls of plasma; anti-mass generators; vortex propulsion; suppressed technology; government cover-ups; gravitational pulse drive, spacecraft & more.

240 PAGES. 7x10 PAPERBACK.Heavily Illustrated. $14.95. CODE: AGU

ANTI-GRAVITY AND THE UNIFIED FIELD
Edited by David Hatcher Childress

ETHER TECHNOLOGY

A Rational Approach to Gravity Control
Rho Sigma

This classic book on anti-gravity & free energy is back in print and back in stock. Written by a well-known American scientist under the pseudonym of "Rho Sigma," this book delves into international efforts at gravity control and discoid craft propulsion. Before the Quantum Field, there was "Ether." This small, but informative book has chapters on John Searle and "Searle discs;" T. Townsend Brown and his work on anti-gravity and ether-vortex-turbines. Includes a forward by former NASA astronaut Edgar Mitchell. Don't miss this classic book!

108 PAGES, 6x9 TRADEPAPER, ILLUSTRATED WITH PHOTOS & DIAGRAMS. $12.95. CODE: ETT

ETHER-TECHNOLOGY
A Rational Approach to Gravity Control

Forward astronaut Capt. Edgar D. Mitchell, Ph. D.

by Rho Sigma

THE UNDERGROUND CLASSIC IS BACK IN PRINT!

MYSTERY CITIES OF THE MAYA
Exploration and Adventure in Lubaantun & Belize
by Thomas Gann

First published in 1925, Mystery Cities of the Maya is a classic in Central American archaeology-adventure. Gann was close friends with Mike Mitchell-Hedges, the British adventurer who discovered the famous crystal skull with his adopted daughter Sammy and Lady Richmond Brown, their benefactress. Gann battles pirates along Belize's coast and goes upriver with Mitchell-Hedges to the lost city of Lubaantun where they excavate a strange lost city where the crystal skull was discovered. Lubaantun is a unique city in the Mayan world as it is built out of precisely carved blocks of stone without the usual plaster-cement facing. Lubaantun contained several large pyramids partially destroyed by earthquakes and a large amount of artifacts. Gann was a keen archaeologist, a member of the Mayan society, and shared Michell-Hedges belief in Atlantis and lost civilizations, pre-Mayan, in Central America and the Caribbean. Lots of good photos, maps and diagrams from the 20s.
252 PAGES. 6x9 PAPERBACK. ILLUSTRATED. $16.95. CODE: MCOM

DANGER MY ALLY
The Amazing Life Story of the
Discoverer of the Crystal Skull
by "Mike" Michell-Hedges

The incredible life story of "Mike" Mitchell-Hedges, the British adventurer who discovered the Crystal Skull in the lost Mayan city of Lubaantun in Belize. Mitchell-Hedges has lived an exciting life: gambling everything on a trip to the Americas as a young man, riding with Pancho Villa, his personal quest for Atlantis, fighting bandits in the Caribbean and discovering the famous Crystal Skull.
374 PAGES. 6x9 PAPERBACK. ILLUSTRATED WITH MAPS, PHOTOS AND DIAGRAMS. BIBLIOGRAPHY & INDEX. $16.95. CODE: DMA

IN SECRET MONGOLIA
Sequel to Men & Gods In Mongolia
by Henning Haslund

Danish-Swedish explorer Haslund's first book on his exciting explorations in Mongolia and Central Asia. Haslund takes us via camel caravan to the medieval world of Mongolia, a country still barely known today. First published by Kegan Paul of London in 1934, this rare travel adventure back in print after 50 years. Haslund and his camel caravan journey across the Gobi Desert. He meets with renegade generals and warlords, god-kings and shamans. Haslund is captured, held for ransom, thrown into prison, battles black magic and portrays in vivid detail the birth of new nation. Haslund's second book *Men & Gods In Mongolia* is also available from Adventures Unlimited Press.
374 PAGES. 6x9 PAPERBACK. ILLUSTRATED WITH MAPS, PHOTOS AND DIAGRAMS. BIBLIOGRAPHY & INDEX. $16.95. CODE: ISM

MEN & GODS IN MONGOLIA
by Henning Haslund

First published in 1935 by Kegan Paul of London, Haslund takes us to the lost city of Karakota in the Gobi desert. We meet the Bodgo Gegen, a God-king in Mongolia similar to the Dalai Lama of Tibet. We meet Dambin Jansang, the dreaded warlord of the "Black Gobi." There is even material in this incredible book on the Hi-mori, an "airhorse" that flies through the air (similar to a Vimana) and carries with it the sacred stone of Chintamani. Aside from the esoteric and mystical material, there is plenty of just plain adventure: caravans across the Gobi desert, kidnapped and held for ransom, initiation into Shamanic societies, warlords, and the violent birth of a new nation.
358 PAGES. 6x9 PAPERBACK. 57 PHOTOS, ILLUSTRATIONS AND MAPS. $15.95. CODE: MGM

IN SECRET TIBET
by Theodore Illion.

Reprint of a rare 30's travel book. Illion was a German traveller who not only spoke fluent Tibetan, but travelled in disguise through forbidden Tibet when it was off-limits to all outsiders. His incredible adventures make this one of the most exciting travel books ever published. Includes illustrations of Tibetan monks levitating stones by acoustics.
210 PAGES. 6x9 PAPERBACK. ILLUSTRATED. $15.95. CODE: IST

DARKNESS OVER TIBET
by Theodore Illion.

In this second reprint of the rare 30's travel books by Illion, the German traveller continues his travels through Tibet and is given the directions to a strange underground city. As the original publisher's remarks said, this is a rare account of an underground city in Tibet by the only Westerner ever to enter it and escape alive!
210 PAGES. 6x9 PAPERBACK. ILLUSTRATED. $15.95. CODE: DOT

24 HOUR CREDIT CARD ORDERS—CALL: 815-253-6390 FAX: 815-253-6300
EMAIL: AUP@AZSTARNET.COM HTTP://WWW.AZSTARNET.COM/~AUP

One Adventure Place
P.O. Box 74
Kempton, Illinois 60946
United States of America
Tel.: 815-253-6390 • Fax: 815-253-6300
Email: aup@azstarnet.com
http://www.azstarnet.com/~aup

ORDERING INSTRUCTIONS

➤ Remit by USD$ Check or Money Order
➤ Credit Cards: Visa, MasterCard, Discovery, &
American Express Accepted
➤ Call ♦ Fax ♦ Email Any Time

SHIPPING CHARGES

United States

➤ Postal Book Rate { $2.00 First Item / 50¢ Each Additional Item
➤ Priority Mail { $3.50 First Item / $1.50 Each Additional Item
➤ UPS { $3.50 First Item / $1.00 Each Additional Item
NOTE: UPS Delivery Available to Mainland USA Only

Canada

➤ Postal Book Rate { $3.00 First Item / $1.00 Each Additional Item
➤ Postal Air Mail { $4.00 First Item / $2.00 Each Additional Item
➤ Personal Checks or Bank Drafts MUST BE
USD$ and Drawn on a US Bank
➤ Canadian Postal Money Orders OK
➤ Payment MUST BE USD$

All Other Countries

➤ Surface Delivery { $5.00 First Item / $2.00 Each Additional Item
➤ Postal Air Mail { $10.00 First Item / $8.00 Each Additional Item
➤ Payment MUST BE USD$
➤ Checks MUST BE USD$ and
Drawn on a US Bank
➤ Add $5.00 for Air Mail Subscription to
Future *Adventures Unlimited* Catalogs

SPECIAL NOTES

➤ RETAILERS: Standard Discounts Available
➤ BACKORDERS: We Backorder all Out-of-
Stock Items Unless Otherwise Requested
➤ PRO FORMA INVOICES: Available on Request
➤ VIDEOS: NTSC Mode Only
PAL & SECAM Mode Videos Are Not Available

European Office:
Adventures Unlimited, PO Box 372,
Dronten, 8250 AJ, The Netherlands
South Pacific Office
Adventures Unlimited NZ
221 Symonds Sreet Box 8199
Auckland, New Zealnd

Please check: ☑
☐ This is my first order ☐ I have ordered before ☐ This is a new address

Name	
Address	
City	

State/Province		Postal Code	

Country	

Phone day	Evening
Fax	

Item Code	Item Description	Price	Qty	Total

Please check: ☑

☐ Postal-Surface

☐ Postal-Air Mail
(Priority in USA)

☐ UPS
(Mainland USA only)

Subtotal ➤	
Less Discount-10% for 3 or more items ➤	
Balance ➤	
Illinois Residents 7% Sales Tax ➤	
Previous Credit ➤	
Shipping ➤	
Total (check/MO in USD$ only) ➤	

☐ Visa/MasterCard/Discover/Amex

Card Number

Expiration Date

10% Discount When You Order 3 or More Items!

Comments & Suggestions	Share Our Catalog with a Friend